"Stephan has such a Life is a work of art gazing through Stephan's imagination. Stephan's words should be written in the sky."

SINEAD MCGUIGAN
Author of Unbound, and A Gift and a Curse

"Yesterday I received "the silence between what i think and what i say", within a few pages emotions began to overwhelm me, single parenthood, love, and loss, wishes, desires, present and time, tears... congratulations on capturing the human condition, not since encountering Jorge Luis Borges work, especially his "Everything and Nothing", has my intellect been so engaged with images of truth and beauty so effortlessly expressed."

DENNIS FOY
Chef and Artist

"I love every single one of Stephan's poems. I am obsessed with Stephan's books and so are my friends too. I am enjoying every single word. It's truly fascinating, engaging, refreshing and very easy to relate with. Stephan made me find the pleasure of reading again. The poems I read in the morning help me start the day in a much better spirit. I also read a page of Stephan's book every night and it's like a great medicine and therapy. Every word Stephan writes makes me feel better every day. Life is art and so are Stephan's writings and the way he sees life and describes his feelings. Thank you, Stephan."

ALEX BILBAO

"Stephan's poems are breathtakingly beautiful. Stephan has always been one of the kindest, sweetest, most gentle people I know. Stephan has so much talent. He is such a bright light."

LEAH VITALE

"Stephan is so talented with a heart of gold and his heart is in every poem single poem that he writes."

<div align="right">VIVIAN CAROVILLLANO</div>

"Stephan's writing is beautiful. Stephan has a poet's soul. Someone out there is lucky to have him writing about her (them). His writing is heartfelt, honest, and inspiring. Stephan's writing speaks to my soul every single time. I love his writing. It relaxes me."

<div align="right">DESTINY DOUGLAS</div>

"I just bought Stephan's second book, "tonight will be the longest night of them all" and I love it. Thank you, Stephan, for sharing so much of your life. It's beautiful."

<div align="right">DORIEN JAEGER</div>

"I just finished Stephan's book, "the silence between what i think and what i say" and it made me feel inspired, circumspect, sad, questioning, sad again and inspired again. I will use a term that is probably no longer in Stephan's vernacular: 'Fucking-A' ... truly wonderful. I thank him for sharing"

<div align="right">PETER HEIDT</div>

"I had a wonderful day with my family and got home and read them all a few pages from Stephan's book "tonight will be the longest night of them all". We settled on one in particular that stood out, "is she ok", as it left us all thinking on who we are as kids ... and me as a parent. I love Stephan's books. I read them often with my children. I don't have all (any) of the answers. All I can do is be a guard rail and support them. And Stephan's words help. I look forward to more reading to share with my kids and some I'll keep for me. Stephan's words are so special and real. I love Stephan's books. I read them often with my children."

<div align="right">BRIAN BECK</div>

"I read Stephan's words, selecting a page randomly, and his words always resonate. Stephan's books are on my desk at work, and they always give my brain some space to breathe.

KRISTINE GARLISI

"Stephan's words are like feathers sensationally touching the heart"

HELEN BADER NASRA

"Stephan's books are beautiful spiritual, and unique." "I have read these words in Stephan's books, and no matter how many times I read his words, they ALWAYS touch my soul. Thank you, Stephan, for your insight, your compassion, and your heart, but most of all thank you for sharing them with us. Blessings to you always. Stephan's words touch me at the core of my being. I need to read his poems again and again. No matter how many times I read his poems, they always touch my soul and my spirit. Stephan's beautiful great and soul can be seen through his sweet words. I can only thank Stephan for his insight, his compassion, his heart, but most of all for sharing his words with us."

CINDY CONRAD

"Stephan is such a rare talent. All of his words are so moving and so poignant. Stephan is an amazing poet."

CAROL NOBBS

"Stephan's elegance and beauty shines through exquisitely in his poetry. The descriptive language of love and things treasured takes my breath away. Stephan has an incredible warmth in the way he communicates. Stephan's words are a feast for the senses."

DIANA MONTANI

"Stephan's words have excruciating verity."

<div align="right">LIZ SCHORN</div>

"Each of Stephan's poems reads like a short story that is so personal. Stephan's words are a beautiful escape. So meditative and always reminds us of what's important."

<div align="right">ABBY SCHWARTZ</div>

"I connect with Stephan's thoughts, and then evaluating and thinking - and feelings happen. It's not just the words Stephan chooses, but what they invoke in everyone."

<div align="right">RICHARD SCRAGG</div>

"I am learning different ways to be quiet. Thank you Stephan for teaching one way through your poems."

<div align="right">AAHNA ANAAYA</div>

"Stephan's poetry is beautiful, moving and touching. Stephan is truly a delight. Thank you for sharing your beautiful words."

<div align="right">CAROLYN SWEETAPPLE</div>

"Stephan's poems are words to live by. I can relate to each line."

<div align="right">LAUREN SERVIDIO</div>

"Stephan's poems are the simplest of wisdom and gentle optimism when we all so desperately need it, young and old alike. Thank you for sharing Stephan."

<div align="right">DARA SAOL</div>

"Love is the essence of life and I really appreciate Stephan's beautiful writing. Kindly, Stephan touches our hearts with his words."

<div align="right">ANA CRISTINA
Artist</div>

Also by Stephan Silich

The Silence Between What I Think and What I Say
BROOKLYN WRITERS PRESS (2018)

Tonight Will Be The Longest Night of Them All
BROOKLYN WRITERS PRESS (2020)

Putting The Trembling Kiss at Ease
BROOKLYN WRITERS PRESS (2023)

remember me as a time of day

stephan silich

BROOKLYN
Writers Press

Copyright © 2024 Stephan Silich

All rights reserved.
Published in the United States of America by the Brooklyn Writers Press, an imprint of the Brooklyn Writers Co. LLC.

brooklynwriterspress.com

Thank you for purchasing an authorized edition of this book and for complying with copyright laws. No part of this book may be used or reproduced in any manner whatsoever without written permission except in the case of brief quotations embodied in critical articles and reviews.

For permissions or information on bulk orders, please email: contact@brooklynwritersco.com

TITLE: *Remember Me as A Time of Day*

ISBN 978-1-952991-33-2 (e-book)
ISBN 978-1-952991-34-9 (paperback)
ISBN 978-1-952991-35-6 (hardcover)

Library of Congress Control Number: 2024905907

1st Edition

Cover Design by Stephan Silich and Martin Endemann

again...

for my daughters, emma and mia.
for my brother, robert.
for my parents, robert and dianne.

as always, this is for you.

(dad, i miss you and hope you can still hear me.)

"Come sit with me and be at ease. To look upon these wondrous trees and feel some heaven in every breeze."

Bench Plaque — Central Park, New York

contents

the worst day	16
mom	19
photo album	22
the magic of music	23
words	24
the buddhist moon	25
prayers	26
the edges of eternity	27
your presence	28
sensitive misfits	29
the flower	31
poetry	32
illuminated	33
a fleeting glimpse	34
lost	35
career day in kindergarten	36
the eternal song	37
existence	39
a letter written to those who have lost the one	40
children	43
smiling on the inside	44
life	45
absence and presence	46
prized possession	47
it's not quitting	49
broken pencil	51
the overweight schoolgirl	52
wait	53
tilt	54
it hurts	55
music	56
what sustains is what remains	58
fall	60
sunlight	62
our exhausted collapse	63

a near perfect day	64
she is	66
the meaning of you for me	67
the simple words	68
urgency	69
in your absence	70
contemplation	73
smile	74
under the covers	75
sunrise	76
writing about mortality	77
the promise of you	79
create don't complain	80
this moment	82
our home	83
hope has a broken heart	85
asleep	87
prolonged grief disorder	88
too deep for tears	90
the truest parts	91
an elegy	92
nice try	93
some ideas	94
the small i	96
i miss you	97
stardust	99
absence	101
safe	103
the diplomacy of mercy	104
such as you	106
couldn't ask for anything more	107
what to do	108
let it sing	109
life and death	112
sweet thoughts	114
the release of love	115
moonlight	116
permanence	117

still	118
you are a work of art	119
only humans cry	120
telescope	121
my dad's dying breath	122
live	124
love letter	125
some questions	126
your songs	127
grace	128
equal	130
some things i don't like	131
prayer	133
the sweetness of life	134
being a father	137
your eyes	138
privacy	139
still left to be lost	140
pure	141
for you	142
despite my broken heart	143
59 stars plus 1 moon and 1 large star	144
a heart	147
the candle	148
love	149
by the sea	151
there will be	152
the sweetness of life	153
talk to me	154
emma and mia into the bed	155
the great reward of love	157
the end	158
sacrifice	159
the moon	160
passing	161
the poetry of life	162
love	163
always	164

the richness of life	167
triumph	169
our little garden	170
life	172
from the heart	173
childhood	175
i don't want to ever say goodbye	176
goodnight	177
i don't want to leave	179
the puzzle	183
our time	185
some more advice	186
78.7	189
childhood	191
for you both	192
these words, this life	193
our beginning	195
the sunflower or the sun	197
close your eyes	198
thank you	200
1,000 ways back	201
all flowers, in time, bend toward the sun	202
task	203
flowers	208
eternity	209
otherness	211
remember me as a time of day	213
postscript	214
you	215
where i'm from	216
the silence in me	217
Acknowledgements	218
About the Author	220

the worst day

someone asked once,
what was the worst day of your life?
and for me
it was sunday, september 6th, 2020.

the day i said goodbye for the night
to my daughters, emma and mia
(7 and 5 years old at the time).

i quietly closed the door
and walked down the hall,
away from their mother's apartment.

in the elevator i could barely breathe
let alone focus
on the right button for the lobby.

i left the building
and walked to my new apartment,
counting each of the 237 steps along the way.

i walked right past my building
and kept walking for about an hour.

it was the quietest night i have ever known.
i have still not recovered.

i hear their voices in every song.
i hear the haunting echoes
hidden in every seashell.
and i hear all that is beautiful
as they sing to me
while breathing in their sleep.

for a brief moment,
i was able to slow down the inevitable,
with three years on the couch
and a pandemic that brought us together

under one roof for an extra six months.

we live now in two homes
and the division of time
and even the division
of their school artwork
still breaks my heart.

i'm trying not to miss any first moments.

the terror of realizing
i would spend half of each week,
each month,
each year,
each decade
without them
makes these tears etch permanent scars on my face.

i always believed
that even the planets and stars
could be slowed
by standing in the place
you hold sacred and dear,
and i tried just that.

what will happen with these unrecorded hours?

how will i calm my spirit of uncommon sensitivity to the beauty
and horror of this life?

i will, however, spend every day with them,
filling in as many small moments of touch as possible.

i will keep a close eye on everything they do
and notice all the things that tend to go unnoticed.

in the end,
i know the loveliness held for longer
than i had any reason to hope,
and now, we do actually have enough time

to be kind to each other.

this entangled life
that was woven together
over years has unraveled a bit,
but the divide will be mended.

we will gently awaken to each day.

we will run with the bees
from flower to flower.

we will search to find a thing or two
that was once true.

your small, warm bodies
pressed against me
as we sleep under the stars
reminds me that all is
too empty when you are gone
and too full when you're with me.

i will live with this question,
which is the answer:

how can i help you feel more loved?

note: i wrote this poem on wednesday, april 5, 2023. i calculated it has been 971 days since sunday, september 6, 2020. i have cried every single day at some point after hearing a song, seeing an image, or just thinking of them. i am present every minute of every day. those 971 days of tears have been an absolute privilege and some of the most beautiful days of my life. and it continues...

mom

i know now that you carry me
with you all the time.

you gave me the difficult courage
of authenticity.

you taught me
there is a more meaningful way of being
and not to look at everything
in terms of gain and loss,
as either an advantage or a disadvantage.

you cultivated in me
the supreme quality of human warmth.

you have always been
unpretentiously beautiful
and quietly profound.

because of you,
i enjoy art,
read to my children,
listen to birdsong,
watch sunsets,
know the meaning of goodness,
and am moved to tears by music.

because of you,
i embrace all the hallmarks
of our humanity
and the fidelity of feeling.

because of you,
i will never chip away
at our shared sense of truth.

because of you,
my resolutions

don't fade like stars at dawn.

because of you,
i absorb the beauty and wisdom of words,
and i know that poetry is the language
for the silent places in me.

because of you,
i live with compassion
and generosity of spirit.

because of you,
i can disregard the echo
of judgments and opinions.

because of you,
i enjoy every day of life,
even the moments of sadness
and the solitude of aloneness.

because of you,
what was possible has been done.

because of you,
i return each morning safe from sleep.

because of you,
i am unafraid of knowing my own depth.

because of you,
i strive for effortless kindness.

because of you,
i can hear the blood in my veins;
i can see the shadow of the trees trembling.

because of you,
i have been immensely rewarded
with a full life.

and because of you,
i beg you to stay just until tomorrow.

photo album

my eyes full of exhaustion,
but never giving up.

i will remember all the faces
i have loved
like pages in a family photo album.

i will hold on to the love
and not the hurt
because it's love that is the redemption,
and love that is always the triumph.

the magic of music

the river is flowing.
the stars are burning.

my wandering feet
at last
turn home,
guided by the distant magic of music.

i listen for it.
it sharpens my senses.

this is the muted victory,
so let me kiss your cheeks
for every year of your age,
that's 10 for you, emma,
and 8 for you, mia.

when the sun grows low on the horizon,
recollections will fade a little,
memories will recede a bit,
but you will always
stay closest to my heart.

words

i don't want to overstate this,
but these words that rise
from tender - back to thundering
back to tender again
are expressing something essential
about the moment
just before you are confronted
with the lies and compromises
of day-to-day existence
and how to survive the exiting of youth.

hold on to this.

hold on to these feelings.

hold on to hope.

hope is 1,000 flowers blooming,
and it exists for many of us.

there is an undefinable authenticity
to life's beginning,
to life's blossom.

these words will wait to reach you.

i'm not worried.

i just found them a place to live for now.

the buddhist moon

what are the rewards of silence
when there are voices speaking of love?

and these voices speak when life moves toward
midnight's darkness
as time walks by unseized.

dying more to live more,
we breathe into heaven
and escape to our solemn hours.

i sit with you
under tonight's buddhist moon,
surrendering to this moment's resolve,
postponing the beating of wings,
arms open to the world
and to this—our ocean of love.

prayers

will my prayers
to the world be realized?

will they see
the streaks of tears written on these pages?

will they believe
a few words record an entire life's struggle?

will grief be rekindled by a final loss,
or will it be grieving for the end of possibility?

will they know
this day will speak louder
than all the bombs they can drop?

will they understand
that it's the privileged hours
lying in bed with you,
reading that book,
and listening to that song
that allow me to realize
it's good to just be here
in this moment
with all its tribulations and triumphs,
with our glimmer of enchantment,
our shared secrets,
and our passing of time.

the edges of eternity

let the dream of tomorrow
unfold across the horizon.

stay pensive and languid
and full of dignity.

be bracingly honest.

hold an adoration for whispering.

keep the attraction for living
and lingering on the margins.

be a prophet for sublimity.

practice a little humanistic romanticism.

have a sensitivity to aliveness and awareness,
and keep your capacity to be moved by everything.

always go with solitude;
it's inhabited by memories anyway.

and those memories will allow
history's voice to run through the centuries,
where our love remains on the edge of eternity.

your presence
(for emma and mia)

all i long for
is your undeniable presence
because beneath the layers
of your time
and memory
and history,
i've been drifting
through the mournful evidence
of these days without you.

the rhythmic beating of my heart
grows stronger every moment,
hardening my purpose,
because time and love is all we have.

each morning i wake,
it is there with me all day
and there with me all night.

a glimpse of the divine.

the expression of anything and everything.

the ambient sense of meaning
is found in you,
and the blink of your eyes
is the rest of my life.

sensitive misfits

time seems to bend around us
like the wind does the trees
as we live through these
days upon days of togetherness.

let's be the sensitive misfits that we are.

let's disregard the cultural obsession
with accumulating and accomplishing
as much as humanly possible.
it's not needed.
it never was and never will be.

stay aglow with hope,
even if tinged with despair.

don't squander your youth
in the hall of mirrors.

value art and ideas.

obliterate the desire to possess things.

ask heroic questions.

ask for help if you need it.

work doesn't have to satisfy you,
especially if it's no longer relevant
to the person you are.

question the notions of beauty
and who actually decides what is beautiful.

to what end beauty anyway?
and does it even matter?

who cares about the smooth face?

the modern art you can't afford?
the faraway trip you can't take?
the glittering interior you'll never have?

look for the clarifying moments in your reflected life.

forget the vulgar displays of wealth and fame.

celebrate life for its ephemeral beauty:

it's comings and goings
it's appearances and disappearances
it's presence and absence.

keep the integrity of fidelity
and your staggering fragilities.

maybe then we can come to terms
with death as part of life.

because death happens in life,
it doesn't happen to life.

the dreamless sleep awaits us all;
accept it the best you can.

endure the night,
and maybe joy comes in the morning.

be at ease with change.

let's remember
that every human mind wanders,
and we miss a large part of it all.

let's repeat this again and again.

let's make the most selfless use
of our present moment.

the flower

even the edges of my teeth hurt
longing still for your arms around me.

you will remain the ache within the ache
because you are the flower that split the rock.

poetry

poetry is the only thing
that can't be corrupted.

it is the simple words
that should be celebrated
because the echoes of these pages
open boundless spaces around you.

sit with the forgotten.
listen to the unheard.

let the truth of aliveness arrive,
along with noble thoughts
and virtuous actions
of what it means to love,
of what it means to live.

illuminated

my love for you
is a weightless element
that hovers above the clouds
leaving astonishingly
indelible imprints
on what you cannot see
but always feel.

my love for you
is expressed in these hushed words,
touched by some blessing
that will survive all of this,

displaying the glory of life
and all that is illuminated
under the winter moon.

a fleeting glimpse

at the end of the day,
i did catch a fleeting glimpse
out of the corner of my eye
and it shaped my life.

i know now
there is light that pours through mountains.

i know now
there is wine that pours through veins.

i know now
there is frailty that becomes
part of the finished portrait.

i know now that the echo of our experience
will show the rising and the falling
and the rising again.

i know now
there are a hundred years of beauty
awaiting us
over rooftops,
under bridges,
and across the land.

lost

i lost it all with my eyes wide open.

career day in kindergarten

mia comes home from school
and says she wants to be

"a girl who picks flowers and puts them together for people."

"a florist, mia?"

*"yes—that's it, daddy, like ms. sarah.
can you get me a piece a paper so i can write the name?"*

mia grabs a box of crayons
and writes out the letters, spelling florist,
with each letter a different color:

f is red
l is orange
o is green
r is blue
i is pink
s is purple
t is yellow.

mia,
my dear little girl,
you have
the heart of a poet,
the eyes of a photographer,
the hands of a painter,
and the soul of a saint.

the eternal song

how life unfolds in public spaces,
subways and sidewalks,
parks and tree-lined streets,
museums and libraries.

reflecting on the passage of time
as earth orbits around the sun
at 67,000 miles per hour.

do i know something about life
that could be of help to you?

if i do,
is there a way to pass this on?

it's a life
primarily lived in solitude,
which i always enjoy;
never avoiding
any pauses in the day
where feelings crept in.

this river of change
is what i always long for.

you are here with me now.

do you hear the unmistakable
notes of gentleness in my voice
when i speak to you?

you gave me this victory.

you also gave me silence,
and you gave me music,
the two things that i always believed
expressed the inexpressible.

so be a little gentler with yourself.
be kinder than you dare to people.

live more fully.
love more deeply.

keep your lightness of touch

your scent of youthful slumber

your soul full of harmony

your absence of personal vanity

your unfailing consideration

your rising above misfortune,
which still stirs my human heart

your affliction by despair,
but still managing to retain joy.

in the lonesome shadow
of these new york buildings,
you stand with due care,
naked for all to see,
as the eternal song
arrives unannounced
every hour of day
and every hour of night.

existence

wrenching myself into existence
by softly pressing this pencil to paper.

a letter written to those who have lost the one

i want to find the right words,
the good words,
the ones reserved for prayer.

we are born knowing how to cry
because the first sounds we make
are more often than not
the sounds of weeping.

will the poets help?

will the prophets lend a hand?

how do we get through these
relentless, awful occasions?

the only way out of grief
is the way out of all things:
straight through.

it's not to be overcome or resolved.
it's to be lived.

the physical presence is absent,
and that absence remains and always will,
but you can melt the person
into your life again
in a new way.

in the midst of our mourning,
the grieving comes in waves
and you never really know
when the next
will pull you down a bit.

all you can do is listen
for the voiceless whispers of your parents.

they are speaking to you now.

they are telling you to live.

so live with the dreams,

dreams that are
as capable of moving you as ever.

live with these moments,
and let the graceful notes
of your one and only life continue.

the pain of losing them
comes from the joy of loving them.

the astounding thing
is we inherit the virtues and values
of those we love,
so in that regard,
death can sometimes be a little useful.

you will not forget the void,
but you will relearn how to live.
and relearn you will.

the permanence of their presence
will guide you with stillness.

you will live more tenderly now.

you will want to speak softly rather than scream.

you will be brought to tears
by the kindness of others,
the laughter of children,
the full moon in the night sky,
and the sound of the unspoken happy language of lovers.

our time has a term,
and it's not inconceivably distant.

so live with more honesty,
more truthfulness,
more contented hours than ever before.

the wounded heart
knows the essence of healing.

it will cultivate
a luminous affection
for humanity's closeness.

your aching
will bring
a yearning
for what is attainable through
this profound and durable instant
when you are most alive.

there will never be infinite darkness;
there will never be loss of hope,
for hope is what allows tragedy to befall us,
but there is no other way.

always laugh as much as you cry,

and remember
the entire landscape of life
and the history of human existence
is unfolding
with the awareness
that this is all
just a fantastic miracle.

children

i think of children,
all of them,
and it always makes me cry.

smiling on the inside

> "daddy, i know you were mad at me last night
> because i wouldn't go to sleep,
> but i know you love me,
> and i know you were smiling on the inside."

these fragile words
remind me that it's always the little things...

emma's sweet precociousness in
always saying what's on her mind
is only matched
by her sister mia's eyes wide open,
watching us and learning something new every day.

still growing
and lush with pure love,
you give me everything
i ever needed.

i've now lived a century of life with you in my arms.

life

life, exhilarating and daunting,
will be defined by a longing
for what you cannot name.

your solemn secret stirrings
will fill the gaps in time and space
and the unknown future into which
we will fall.

the earnest yearning and howling
that you struggle to contend with
will make you realize what is closer to you
is farthest still.

life continues to undergo
this particular and urgent crisis
as our hearts continue
bursting like stars,

the same stars we see in the night sky
that have been formed by light
sent from vast, immeasurable distances
across the universe
and straight to us
to feel deep inside
now and through
the quiet hours of morning.

absence and presence

the thing that makes you cry
knowing it's no longer there

is the same thing that will make you cry
knowing it existed for you alone.

prized possession

my 8-year-old emma
on her school video class
was asked to go grab her most prized possession
in the house and tell the class why.

emma ran over,
grabbed me by the hand,
and pulled me in front of the computer screen
and said: "this is my dad."

the teacher asked:
 "emma, is this your most prized possession?"

emma said:
 "of course. it's my dad."

why? the teacher asked.
 "because he always loves me, and he is a lot of fun."

the teacher replied:
 "wow, that's absolutely wonderful!"

i smiled and waved
and walked away from the computer
so the class wouldn't see the tears
starting to make their way down my face.

i went outside to the yard
among the birdsong,
the cardinals,
the doves,
the bluebirds,
the hummingbirds,
a few rabbits roaming,
a deer in the distance,
a hawk above,
a wild turkey near,
the breeze through the trees,

and me alone with this
heart-thumping gift of immeasurable love.

it's not quitting

sometimes it's not quitting,
but just letting something go.

it's the sacred edges of life
the triumphs and the tragedies
the loss and the gain
the glory and the devastation.

through it all,
human kindness and dignity
and their eternal importance
will prevail.

listen to the song that sorrow sings
and live in the dream of today.

maybe we can play finer music now
and have everyone sing along for a while.

let's not worry about things that might happen;
worry when it happens.
and even then, don't worry too much.

view life with limited time in front of you
so it gives you the ability to focus on
the meaning in the moments
and not on some future that may never be.

stay on the side of revelation.
stay on the side of beauty.

it's ok to hold on to the memory
of when things were once magnificent.

it's ok to hold on to nostalgia
for the moments lived to the fullest.

these living moments

of elation and plenitude
are often those same moments
that you would never think mattered.
but in the end, those are precisely the ones
that will delicately and beautifully stay with you
for the rest of your days.

broken pencil

my work is being forgotten.
my career is coming to an end.
my life is full of small victories
and large defeats,
but everything pulls me to you.

everything you do becomes
an ode,
a chorus,
a caress,
a serenade,
an elegy.

just watching my 5-year-old daughter
break her pencil
as she tries to write her name
becomes a soft memory
that will carry me through
the distance of my life.

my love will surely be your inheritance,
bequeathed to you, little ladies,
with complete and utter devotion.

and that's all that matters.

the overweight schoolgirl

i look at the overweight schoolgirl
in her plaid uniform
and marvel at her laughing, kind eyes.

i notice a hint of sadness,
so i look away and stare
at the sticker on her school bag
that says:

"love... it takes two"

my stop is up.

i head off the bus
and smile goodbye.

she smiles back
and gives a slight wave.

i wave back
and realize she was right:

love... it does take two.

wait
(wednesday, september 21, 2021)

walking to work
after dropping off my two girls
at school,

i listen to the mourning violin
straining in my headphones.

pass a mom
holding her daughter's hand on the corner.

squint at the sun making her way through the trees.

then pass a dad
holding his young son closely, tenderly in his arms.

and the weeping begins
ever so quietly and
ever so slowly.

i search for something
to say to myself,
but the melancholy
blurs my words at the edges
and i realize today is
the autumn equinox,
when the sun creates equal periods
of daytime and nighttime across this planet.

i sit down at a nearby bench,

alone,

and wait.

tilt

your love makes me tilt
toward the sun's rays,
making the days
longer and warmer.

thank you
for the promise of possibility.

it hurts

this extra minute is the day's last gift—

a glimmer across the unreadable page

a reflection of something more breakable with distance

the lamenting and the shimmering

the recognition and the widening

the waiting and the stillness.

my voice and joints ache now.

i feel the pain of someone who has lived a long life.

this life is disquieting, and it hurts.

this life is magnificent, and it hurts.

we love in the face of hopelessness,

create in the face of doubt,

and still choose to continue.

music
(on the 1st anniversary of your death, october 28, 2021)

i listen to a lot more music now
and hear in it the echoes of my father's voice.

the year unfolds,
and i am not prepared for the heart's delight.

i really don't want you to know that
i have not slept an unbroken hour since you left us.

we were with you at the end
as you were with us at our beginning.

you were my most faithful friend,
and i wonder if you ever grasped my love for you.

i know the unfolding of life continues,
burning boundless love,
and the stars shine brighter at night because of you,
as do
the distant mountains,
the deep forests,
the restless seas.

my children have your eyes.

i know your eyes still seek my eyes
because my eyes still seek yours.

i speak to you when you are asleep
as much as i speak to you when you are awake.

if i had a star, i'd give it to you.
if i had a song, i'd sing it to you.
if i had a poem, i'd read it to you.

through these serene rhythms of time,
who could have foreseen such sorrow?

yet amidst all the agony and horror,
the wonder of life,
somehow,
still prevails.

what sustains is what remains

keep in mind,
please always keep in mind,
that you die at the end of all this.

your death will be
completely recognizable,
yet terrifyingly unique.

as we walk the ground
above the bones of our ancestors,
the sun heads down
behind the mountains.

we know the moments
will be lost to time,
yet we also know that
unbridled and exuberant love
exists for us at any moment.

it is ever present alongside us,
and more real than anything else.

the pressed flowers,
the buzzing of the bees,
and the branches of the oaks
allow for a willingness
to be larger than our hurting selves,

to find some treasure
in a world bewilderingly unpredictable.

these consolations
exist alongside the things they cannot console:

the cruelties that unhinge us,
the beauty that clarifies us,
the drugs that don't cure us,
the fleeting possibilities of compassion,

the diseases that deform us,
the residue of nostalgic fondness,
and the small things that sustain us.

fall

i look back on the fullness of our affection
through the four seasons
but stop at autumn
with its suggestion of wistfulness and loss,
sitting on the edge of a solstice,
enveloping us in the immediacy
of unmistakable clarity.

we watch the leaves change
and read fragile poems
that leave us with an ache
that is temperate and unforeseeable.

the turmoil of my soul
is put to rest by the
sound of the little heartbeats in the next room.

surrendering to the enormity
of these moments
and that one night
when true love seemed possible,

my memory becomes a benediction,
and my love becomes a meditation
on time and place,
where there seems to be
no beginning and no end.

each hour passes
with slowness,
yet it all happens
so quickly.

in the middle of these sleepless nights,
the awareness that time is finite is with me,
but so are you,
and your laughter is the triumphant sound of life.

while i am still able to utter words,
the important message i wish to impart
before the stillness sets in
is don't stand on the threshold of despair.

as summer evenings recline,

join the chorus of humanity
serenading
and singing
and shouting
about the bursting celebrations of love.

sunlight

the sunlight
on your bright, curious face
is what guides me through these hours,

redeeming the suffering
and bringing nothing but refinement.

the music of time
reminds us
how the gloriously relentless
beat of your heart
fills the oceans during the tides
and unites the seasons of nature.

our exhausted collapse

we hold each close
until our exhausted collapse
arrives like a moment undone.

our night will tremor before morning.

and tomorrow we will get out of bed
and walk straight into the sun.

a near perfect day
(3:24am on sunday, january 22, 2023)

i'm sitting
at the end
of the bed,
reading.

my 7-year-old mia
and 9-year-old emma
are lying next to me,
sleeping.

we are in springs, east hampton,
in our small house in the woods.

we saved a baby bird
earlier today,
after it flew into our art studio window.

my daughters nursed it back to health
by holding it in their bare hands
and gently caressing its back
and feathers.

they named him max,
and after about 30 minutes,
he shook himself and flew off.

we also fed ducks in the morning,
saw a red robin and a blue jay.

we went for a walk on a nature trail.

then we ate a hot soup dinner in bed
while watching a movie.

they are under the covers,
breathing in and out,
making sleep sounds

that only children can make.
it's the most beautiful symphony
you will ever hear.

this is my favorite thing of all:

the sound of my children sleeping.

it contains all the truth ever needed,
and it is simply the heart of all things.

it is the stillness in the midst of chaos.

it is the calm in the midst of distraction.

it is the only thing i hear.

someday i won't hear it.
someday i will be gone.

but i hear it now.
i feel it now.

and this is all that is ever needed.

i stare at their sleepy hair
with their little beating hearts
and heads full of ideas.

i am present.

this is perfect.

she is

she is quietly tending her garden
as the birdsong sends shivers through my spine.

where do people like her come from?

i worry now about which way i should sleep
because i want to look at her all night long.

she is the reminder
of the nature of human goodness

that some days will stun you with its brilliance

that our faded but durable promise
will remain irreplaceable

and that the emotional swells of existence
will bring endless moments of reflection.

i will always yearningly
ask you one last time,
please don't go;
you are half of me now.

the meaning of you for me

it feels good
to write,
to sit on my terrace,
to find the newspaper waiting for me each morning,
to watch my brother fall in love again,
to go out to dinner with my parents,
to pass the beautiful ones on the street.

it feels good
to know that the meaning of you for me
will remain forevermore
throughout the mountains of tibet
and the grasslands of the serengeti...

a pure, glowing light
never to be extinguished.

the simple words

i am taking a much-needed break.
i am out of breath.

to my surprise,
it will be much harder to say goodbye
than i imagined,
but i will endure
this last bit of humanity.

against these insurmountable odds,
i will dig in
and search for those simple words.

the hymn to the possible
and to the awakening of life.

the words will whisper to me

and from me to you—
saying everything that needs to be said
in the shadow of the sun.

the words will never allow
our hearts to be dismayed,

for our very existence
is our permanent gift.

urgency

the
only
thing
truly
urgent
in
your
life
is
your
next
breath
and
who
you
will
share
it
with.

in your absence

i speak to you today
with feelings
of profound sorrow.

your life was a life well lived,
a promise kept to the fullest
until the end.

and you are mourned
most deeply
in your absence.

you were simply
a piece of heaven
for many of us,
and we all sheltered in your arms,
took comfort in your words,
were lifted by your spirit,
and caught a glimpse
of what is possible
by the way you lived.

our grief is pierced now
with the sweetness of memories
as we continue our longing for meaning,
for truth,
for love,
for something,
for someone.

the light you left
gives us just the right amount of glow
as humanity remains afraid to be kind.

we ask ourselves:

what do we stand for?

what have we done for the world?

how do we wish to be remembered?

is our individuality heroic?

is our character extraordinary?

will we meet our end with serenity?

what does it really take
to be a good human being?

where has the inherent
kindness of existence gone?

i choose to live
with these words
that have been composed by human hands
and this love
that has been orchestrated by a human heart.

many crumble in character,
but you taught me to keep my discernment
and find those who are medicine,
healers cloaked in dignity and tenderness.

i know we can count
on so few people
to stand with us
under the weight of life,
but the devotion
with which i simply love you
shines through everything.

the life that is ours
is not easy or free from pain,
but it is a real life,
a life to spend together as a family,
with the glorious imperfection

of the present moment.

you are the poem.
you are the prayer.
you are the art.
you are the children.
you are the hope.

the splendor is derived
from smallness and subtlety
as our immeasurably breathtaking story
is wrapped always in the expansiveness of love.

contemplation

my calendar is clear.

no dinner parties to attend.
no boss to impress.
no social guests to entertain.
no false laughter to hear.
no hollow compliments to receive.
no networking to suffer through.
no business cards to hand out.
no cigars to smoke.
no scotch to drink.
no sports to watch.
no women to gaze at.
no movies to sit through.

i will however
move toward what my soul
places the most value on,
which reminds me that
the beauty of us all
is to remain delicately incomplete,
with a spiritual sustenance
and a quiet exultation

and to remember
that the most magical things in life
come abloom not in grand gestures
but in the smallest of moments

and to live a life
that has been enriched
and ennobled by love.

smile

she is
forgiving and timeless,
effortless and endless,
indelible and irrefutable,
sacred and unwavering.

in the most discerning of ways,
she is my solace,
and she is the only person
i have ever met
whose smile
i can actually feel
when i'm not with her.

under the covers

i crawl under the covers.

it is peaceful,
and i'm alone tonight.

the night air
drifts in from both windows.

i shift left,
then right,
then left again
and pull the pillow closer.

i put my arm around the middle of it
and unsettlingly
wait for morning,
knowing that the odds
are impossibly against us all,
but knowing
i will not let this thing go to waste.
i will not let my spirit weaken.

the dream may have ended,
but this is morning,
and these are the songs of life...

and the last memory of my time
will be the upheaval of my heart.

sunrise

history's voice will thunder
across the centuries
and our kiss will never allow
the sunrise
to leave us unmoved.

writing about mortality

i write about mortality
because at age 16
i discovered
that everything goes away
and that it can do so at any moment.

an act of pure horror
as i witnessed the decapitation
of a young mother
and the terror-filled
moment occurring in front of her husband
and 2 young daughters, ages 7 and 5.

i have never recovered from this,
but it has guided my daily behavior.

and although there have been
countless sleepless nights
through the chaos of existence,
i have somehow found a calmness of spirit.

i am grateful beyond measure
at the awe that still inspires me.

i allow the nature of time to pass.
i leap after the quiet dreams.
i remember the aliveness of life.
i embrace the pure beauty of every moment.

although i am a little tired
of bracing for every fall,
i walk alone under the open sky
and the bare trees,
listening to the remaining leaves
turn in the wind
and know that
everything is interwoven together.

everything is briefly extraordinary
as i hold every hour in both hands,
at all times.

the promise of you

someone must turn the stars,
raise and lower the oceans,
push along the clouds,
grow the trees,
and fill the moon with her soulfulness.

the ancient prayers are answered
by your presence.

i shiver with hope
after every kiss you give me
because we know
not the day
nor the hour
when this exalted existence will end.

i want to feed
the remainder of our time
with this heaven upon us
because the promise of you exists

and the continuation of life
is heard through the echoes
of our newborn children.

create don't complain

i always knew
the best way to complain
was to create.

so here i am,
trying to memorialize
all i love in this life.

a life that i knew
i was fated to leave
earlier than later.

we are all going to leave here,
some sooner than we wanted.

these symphonies of my soul
hold my deepest thoughts
and are the odes
to the privilege of living
and the glory of dying.

everything is a fleeting glimpse,
a momentary epiphany,
a passing instant,
but that is what makes
it all so beautiful.

it is here
and then it is gone.

is earth the right place for love anyway?

is this love designed to vanish,
to be evanescent?

i don't want to cry,
but i break that way.

i still can't read my poems aloud
without weeping.

is any amount of life enough?

i want to disappear in the night with you
so that during our early hours
darkness will slip
across the face of the moon,

and the beautiful mistake we're living in
is nothing more than the urgency of being alive.

this moment

all i ever wanted
was someone who was glad
when i walked into a room.

take my hand
and let me show you
this invitation to understanding.

this moment will remain,
now, today, and in our memory,
as every great love does.

i see you everywhere,
illuminating,
in the shooting star
and in the face of every sky.

I see all the light
shining on the love we made,
and it was a dream away.

make me part of this again;
make me golden.

be aware enough to find more ways to love
because you become what you love.

write your words.
sing your songs.
paint your canvases.
photograph your pictures...

these are the requiems of divinity,
and divinity is found
in the human soul,
and you have awakened me
from near living to full presence.

our home

we grew up in a small english tudor
on staten island
that was over 100 years old.

it had 3 bedrooms
and 1 full bathroom.

my father was a surgeon.
my mother was a pediatric nurse.

it was the first house they bought, in 1973,
and the only home we lived in
as a family for 30 years.

when my parents' friends made more money,
they moved to the nice part of town,
with large swimming pools and tennis courts
and a country club.

we stayed put.

my brother and i grew up
in an incredibly loving family,

with a mom who loved us more than anything
and a dad who treated us like his best friends.

unlike most physicians
who spend their free time
golfing and vacationing,
my dad rarely left his family's side.
my mom was with us every day.

my parents read my first poem
when i was 13 years old,
and it was received with encouragement
and devotion that continued through the years.

i studied latin
for 4 years in high school
and another 4 in college,
and the phrase that always
stuck with me was
"genius loci": the spirit of a place.

and this was our home.

there is no such thing
as a self-made person.

we are the products
of our childhoods,
our families,
our environment,
our neighborhoods,
our parents,
our friends,

it all remains in our pulse
and in your blood.

what is the measure of a good life,
and what does it really mean
to leave a lasting mark
on a very much imperfect world?

the beauty of possessing less to be more.

perhaps it's just mercy,

the mercy of family.

and that mercy
will ennoble your spirit,
reawaken your graceful nature,
and find your divine spark
by extending an affectionate hand
that embraces the quietly resplendent
life of your heart.

hope has a broken heart

in one wandering
almost breathless message,
i hold the essential truth
of this unconditional love,
which is a complete dedication
to my daughters.

it endures regardless
of anything they do
or anything i feel
at any given moment.

this is the crowning glory of my life.

i did my best to be heard.
i wrote down as much as i could.
i always slowed down
and saw what was right in front of me.

i certainly suffer from too tender feelings,
but i am hoping we might be better off because of it.

i have always seen everything
through a veil of tears,
but you have made
the heartbreak
of this life worth living;
even if for a glimpse,
it is all worth it.

i am unusually tired,
especially reflective,
but manage to keep my disdain for status.

i am swimming alone
with the undercurrent of melancholy
laughing and crying
at this world.

i wrap my arms tightly around
the value of memory
and hold on as much as i can
to not be parted from you any longer.

what we make
and how we love
seed into our souls for centuries to come,
allowing us to be led by the hands of grace,
sustained by the words of poets,
and protected by the armor of our art
as we travel to the moon and back
and make it home safe and sound.

my hope has a broken heart,
but it is still beating.

asleep
(october 28, 2020)

our eyes open and close,
open and close again.

your body has found the elegant silence.
your heart has found the exquisite rest.

i have something to tell you.

i really have something to tell you.

please wake up.

please breathe with me again the way you used to.

> *"you are too beautiful*
> *for the world we live in."*

that's what i had to tell you.

prolonged grief disorder

my dad died on october 28, 2020, and i have yet to recover,
2 years, 4 months and 17 days later as i write this poem.

i just read an article about "prolonged grief disorder" and how the american psychiatric association added this entry to the diagnostic manual of mental disorders, 5th edition.

> *for a diagnosis, the definition is intense pain lasting a year after a loss and an inability to resume past activities. it is further defined as the persistent and pervasive longing for, or preoccupation with, the deceased that lasts at least six months after the loss. you must be experiencing persistent difficulties associated with bereavement that exceeds expected social, cultural, or religious expectations.*

i am happy to report that i have been correctly and proudly diagnosed—by myself.

as i jump into my car to pick up some limes and lemons at the local market, the voice memos on my phone come through the speakers, and i hear my 7-year-old daughter emma say:

> *"we sing you a grand lullaby as your name
> is spelled out by the stars in the sky.
> goodnight, grandpa. now sail away."*

next is my 5-year-old daughter mia who says:

> *"grandpa died, but he went to heaven
> and became the best angel in the world."*

this diagnosis is an absolute honor
because in this symphony of time,
with undiminished enthusiasm,
the capacity for hope is found
in our own tender places, together now.

hope is our emblem of being fully human.

hope is our tribute to life
in the midst of incomprehensible loss.

it is our blind hope
and our given love
that pushes us through
the fragility of humanity
and toward the unyielding beauty
of the immensity of being.

too deep for tears

you remind me that if caught at the right moment,
we are all beautiful.

every flower is a flower of you.
every child is a child of you.

i am still moved when i hear your name.
i still weep at the very thought of you.

with palm to mouth,
i will allow these words
to find a way to forgive this life
for its unsparingly human flaws,
including my own,
because all the things we run to
are the things that endearment comes from.

the sense of time passing
allows the struggle for each hour
to be more bearable,

and the love that surrounds my heart for you
is so great it is almost too deep for tears.

the truest parts

without constant work
and constant travel,
you must face
the nature of your existence.

the things you neglected
will no longer be drowned out by the noise.

don't regret what you haven't become;
rejoice simply in who you are.

there is no need to be anywhere
other than where you are standing.

stay calm like the stars in the night sky,
shining eternal,
defiantly out of step
with a fierce devotion to love.

you will become closer
to the truest parts of your soul.

make it a life of quiet anonymity.

keep the fragments of memory
and carry the stone for the marking,

one for a dream

and one for a life.

an elegy

the shape of my heart remains for you.

no more shall we be parted.

the nights are warm and starlit,
and you may hear a lament for the brevity of life.

i weep at the foot of the church,
and walk with the laughter of my father.

i look for the serene moments
amid the terrifying uncertainty of it all.

this is our silhouetted haven,
slightly turned inward and away,
like the darkness that holds together our universe.

we recite an elegy
to the unsung heroes of love,
which is our reminder of the urgency
to make the most of each
and every passing minute.

nice try

every day something tries to kill me,
and it fails.

some ideas

always remember the things that make you cry.
this will let you live closer
to the sources of your inspiration.

escape into beauty.
this will let you realize your dreams.

create art not to make a living.
this will sustain your being.

feel the wetness of every tear.
this will let your smile cover someone's heart.

keep your capacity for empathy.
this will shape the quality of your days.

take a pause in the endless narration of your life.
this will let you enter into the feelings of another.

listening is the key.

a single flower picked can perfume an entire room.

there is always a stick you can use
to scratch stories in the sand.

all the paintings in all the museums
can't match the devotion i have for you.

i will not let my love go unwitnessed.

i will not let my love go unrecorded.

i will not let my love be a thing forgotten.

and i will always remember
to hold my heart with both hands,

and this will be my permanent reflection
of our enduring love.

the small i

question: why do i write in all lowercase?

answer: because i like seeing the small dot
 levitating over the small "i"
 and bringing the big "I"
 down off his pedestal.

i miss you

our home is
forever changed
by your absence,
which is
both distracting
and disorienting.

i am terrified
i will never hear your voice again.

the clouds above
show a shape, then shift to nothingness.

the sun rises higher around us.

the light over the water shimmers.

birds fly above.

the air from a whale spouts up.

the fin of a dolphin arcs.

my daughters run along the water.

their mom picks up shells nearby,
and yet it's the sorrow i still feel.
but this all makes it much better.

i know the grief
has to be tended and lived through,
in whatever form it may take.

i was always certain
of your love for me
and that helps more than anyone will ever know.

your kindness was astonishing.

i miss you.

stardust

if you can hold
the uncommon grasp
of beauty and meaning
inside tragedy and grief,
then all will remain
sacred and radiant,
full of warmth and wonder.

if you become
a little more attentive
to the passing of time,
you can make the rare moments
of pure presence
not so rare.

the journey of our lives
should be filled
with the delights
and enchantments of love,
and it should be a love
that rises above the rivers
and over mountains.

these are our golden days,
our invitation to living,
our celebration of life.

let's hold tomorrow's hand
and make something of substance.

let's drive out to the house
and walk around the backyard
where the ancient and eternal trees
still stand through it all,
watching over our existence
as we move through life
with care and devotion,
living more fully,

loving more deeply,
and noticing everything.

whisper to me again
how there will always
be more love.

and whisper to me again
about how our stardust will
be returned to the stars above.

absence
(march 2020)

one side of the bed unslept in,
a home kitchen without its cook,
a couch half empty,
a walk in the park without a hand to hold,
a bike ride with only 2 wheels,
and a handful of faded letters in a desk drawer.

deserted offices,
mail piling up,
computer terminals off,
plants dying,
books unread,
empty hallways,
closed windows,
and stopped clocks—
time's graceful defeat
and the blurred distance
between memories.

the sound alone of this irreducible sadness
fills me with such longing
that i am untamed by touch
and unwalled by words.

i know that suffering and comfort
live side by side, as they always have,
so maybe someone can bring me hope
in the form of tibetan prayer flags
or some christmas ornaments,
because these fragilities of life
don't just take things away;
they reveal the unrelenting clarity
of what has already been lost.

sometimes loss is just loss
and absence is just absence,
but our continuing existence

will depend on our overcoming
the haunted echoes of these lamentations.

we will look now for a light,
any light,
however faint,
or however dimmed through tears
to shine through our bereavement
and stand at complete attention
to our one and only life.

safe
(november 1, 2021)

> *"daddy, are you there?*
> *daddy, can you hear me?"*

yes, emma, i'm here.

> *"i heard a lady scream,*
> *did you hear that?"*

i didn't hear anything, emma.
there is nothing to worry about.
it just may have been a bad dream.

> *"ok, daddy. can i have a hug and a snuggle.*
> *thank you for always making me feel safe.*
> *i love you, good night."*

good night, emma.

> *"good night, daddy."*

i will pray that i don't forget
these small moments.

emma closes her eyes.

i close my eyes
and say to myself,
tonight everything will be beautiful
and nothing will hurt.

the diplomacy of mercy

the diplomacy of mercy
is the measure of a good life.
don't ache for a perfect one;
it's the good enough one
that prevails.

reach for the alchemy,
the magic by which
the ordinary
becomes extraordinary.

the devastation
and beauty
that this life brings,
along with the frailty
and grace of the human condition,
allows us to howl
with bewilderment
and yearning.

not everything happens for a reason.

don't tell me not to worry.

don't tell me to look on the bright side.

that thinking is nothing more
than an excuse
to avoid tenderness and compassion.

it's impossible to live well
without caring for others.

this is what it means
to leave a lasting mark
on a very much imperfect world.

we can't fit everything worth doing

into one lifetime,
but we can live fully
within our possibilities
and our choices.

small gestures matter.

keep your interest
in the singular beauty of nature:
the insects,
the birds,
the flowers,
the leaves,
the breeze,
the night sky,
the stars,
the soil,
the sand,
the rocks...

the stillness
of stopping to remember,
with memories
as real as a lover's hand
and as alive as a prayer.

let any uncertainty
give way to the present.

there is nothing
other than the now,
the undeniable now.

this will ennoble your character,
reawaken your divine spark,

and allow you to extend an affectionate hand
while embracing your own heart.

such as you

in the stillness of this night,
i sit and think of you.

when i am alone,
i feel you close beside me,
in my heart and in my home.

you remind me of the child
in the back of the classroom
who is always drawing pictures
and knows all the answers
but never raises her hand.

i could search
the world over
until my breath gives out,
and i will never find another such as you.

i'll bring you the time you wanted.

i'll pray for you like falling rain.

you still make me believe the sun is made for us.

and i fall in love with you still
every time you put your sweet hand in mine.

couldn't ask for anything more

a book,
a blanket,
a glorious tree,
a kiss or two,
and of course, you...

what to do

the best thing to give
an enemy is indifference.

an opponent: fairness
a friend: loyalty
a lover: truth
a child: safety
a father: gentleness
a mother: admiration
yourself: honesty
and all humankind: benevolence

let it sing

try not to be swept away with time.

our lives are finite.
some possibilities are limited.
some loves go away.

it's the unforgiving endurance of suffering.

consumerism and our capitalist culture
will continue to rob us
of all sense of meaning,
which is never found
in the pursuit of
labels and brands
or status symbols.

always ask who you are
and what you stand for?

how do you wish to be remembered?
can you alleviate any pain?
can you lift any hearts?
what remains after all this?

and, of course, the answer
to every question is love—
it's the only thing that remains.

live with authenticity
and integrity.

your imperfections
and the impermanence
of our nature
adds to, rather than subtracts from,
the meaningfulness of our lives.

stay under the stars and among the trees.

a poet's job
is to bear witness
and maybe illuminate
the preservation of some nobility,
keeping full of compassion
and boundless love.

with the acceptance of passing
and disappearance,
you will gain an enhancement of being.

remember: you become what you love.

listen to the sound
the sand makes
as it falls through your hands.

do the same with life.

it takes beauty and courage
to love the things in this world
that will be taken from you.

wrap both arms
around the expansiveness of love
and listen for your song.

there's always a song
that wants to sing itself to you.

it's the call for beauty
as you awaken before dawn
to watch the sunrise
or rush to reach the sunset
before the closing of the day.

walk through the night
so the only light glowing on your face
is that of the moon.

and with the last stretch of time,

approach it with joy and wonder.

even though you feel a little sorrow,
do not despair.

let this be an elegy
for a way of life
that perished a long time ago.

put all you have into learning
how to love properly
after all these centuries...

it is the only thing that makes a difference.

life and death

the purest, most tender love
is always that of a parent for their child.

the love for my 2 daughters sustains me
and reawakens me daily to life.

yet i can't stop thinking about the death of my father
as i was just learning to be a father.

i know that everyone we love goes away,
some before us and out of turn,
some alone and scared,
some with warmth surrounded by loved ones.

i remember holding him in my arms;

the person i loved without bounds,
the person i knew loved me the same.

i remember talking to him as he lay dying,
unable to talk back.

it was a quietly sweeping and devastating grief
that still overwhelms me,
but this grief is not an illness.

their pills are not the cure;
their talking is not the salvation.

it's a little like the moon,
our lamenting solitary companion,
slowly moving away from us each day,
part elegy,
part exultation.

so i will, at times,
intimately vanish into these words,

and like the little green shoot,
they will constantly emerge from their seed,
fragmented,
unfinished,
a religious ceremony,
a ritual, a discipline.

i reach down into my bones
for these words that i hope will stay with you,

never becoming a commodity.

and that's because of you, dad.

it's quite simple:

this is the part of me
that's you
and will never die.

sweet thoughts

let me remember this
for all its worth.

the early noises
of the fluttering birds
and all the lovely songs
of our serene surroundings.

these sweet thoughts
will carry me over the clouds
as i disappear away from you,
not because i want to,
but because time has run out.

i wish
you could have heard my words whispered in the yearning.

i wish
you could have felt the warmth of my hand inside yours.

i wish
you could have seen my expression full of hope.

i wish
you could have walked with me to the end with love.

if i think of the right words,
i will send them to you again,
and maybe i can hang on to you a little longer
if only in my dreams.

the release of love

the lonely night is here again.

midweek.

usually wednesday.

i can't escape my heart.

this apartment is an empty place.

where are you, little ladies?

sometimes i cry
and my tears vanish
into the thinnest air,

a perpetually cresting wave.

sometimes, it feels like the collapse of civilization,

the possibility of human extinction.

what stories are possible if you are not here?

can i even tell a story if no one is listening?

if i can't find the light,
should i just run under the night moon?

my relationship to time has changed now.

and time is all we have.

we should not let it slip
irrecoverably into forgetting.

the purpose of it all
is to be overwhelmed by emotion
and allow the complete and absolute
release of love.

moonlight

our moonlight has appeared
and everything changes
on the cusp of sleep
from the waking life
to the sleeping life of dreams.

bathing us in blue
through the windows,
with our collective remembrance,
our musings and reveries.

we breathe and contemplate on
the irrevocability of our love,
pure to the miracles after dark.

this is my love letter
to these winter nights...

the living songs of my heart
that i sing for you only.

permanence

you found me.

you held out your hand,
and here we are now.

making art.
making meaning.
making an effort.

the years of shared life and love
expose our souls
with a willingness to risk everything.

as we struggle for our existence,
the stars slowly burn across the universe.

i will grow old and infirm,
but i will always remember
what we felt together in life.

my recollections
will have a flickering of yours,
and these,
our emblems of existence,
even though impermanent,
will give us a permanence
through love's serenade,
making our tender life
worth every moment
through wind
and water
and soil
and our hearts.

still

still living on the edge of life
with the wounded and the hopeful.

hopeful because to love
one must have hope.

i'm looking for someone
who is looking for me.

and maybe that someone,
in our quietest moment,
will mute the howling ache
and make us feel not weightless,
but perhaps less weighted.

ask yourself,
what does a life with real meaning look like?

can you grow old with kindness?

do you remember the moment right after
and the moment right before?

are you aware that the precious secret
of humanity is our ability to cry?

the questions are always the answers.

and when you find that love,
it will be made bearable
through the aching remembrance of what is possible,
with everything that invigorates
your life together—
art, music,
poems, novels,

and the awe-filled moments
when every face that smiles at you
looks like the opening of a flower.

you are a work of art

with an old voice,
i will tell you my story
like the poets baring their souls,
the musicians strumming their heartbreak,
the painters brushing their sorrow.

but my story will be a happy one,
because of you.

the confusion, complexity,
and uncertainty of life
has turned into something graceful.

no therapists, no psychiatrists,
no coaching, no life gurus,
no medication, no retreats
were ever needed.

in the grand sweep of time,
i was given timeless dedication,
and moments long gone
were immortalized.

the hours of each day are bright.

i speak softly now when i speak of love.

the staggering privilege to live is mine.

you are the fragments of my living history.

you are a work of art,
reminding us of who we are
as the beauty of your life
unfolds effortlessly.

it is your laughter, full of life,
that is life itself,
preventing time from slipping
irrecoverably into forgetting.

only humans cry

i wondered if the sadness i felt
over what had been lost
was going to be a permanent hold,
especially since i wasn't sure
i had the courage to withstand
this particular pain.

after months of heartbreak,
i discovered a small happiness within me,
a deep and promising sense
of the sheer beauty of it all,

and the quiet dignity of those artists,
stately and radiant,
here for us all,
like the tender hands of women
comforting weeping children.

telescope

a love so deep
there is no
adequate language for it.

i held on to it
for as long as i could
because i was young in years,
though weary in spirit.

you were my telescope
to all this beauty
and still are.

you allowed me a lifetime of looking,

bringing life closer
and magnifying the significance
of it all.

where every poem,
every statue,
and every symphony
i've ever known
is about a heart,
standing still,
undiminished.

because nothing
once created
can ever fully leave us,
and we remain
like two stars
exploding nightly in the sky.

my dad's dying breath

these are my loneliest moments...

the ones when i try to compose
the rare recording
of these infinite writings.

i am torn apart, but i am saved
as these quiet hours turn into years.

i still shudder
with the tenderness of knowing
how like the moon in the arms of the stars,
i too have to share
our staggering fragility,
as i carry you with me, always.

i will remain a child
and enter fully into the light of life.

i will love you and all of your pieces.

i have promises to keep
and stories to tell
that allow me to remain beholden
to this ordinary life that is mine.

i have always felt a sense of unease
about almost everything.

and there has always been something inside me,
scratching at my heart,
telling me to disregard the effort,
blot out the ache of consciousness.

i embrace the thoughts of my dying father
and how i was at once a witness
to the entirety of human existence.

each of us was given a moment alone with him.

and with my hand over his still-beating heart,
i whispered in his ear
that i would leave this life
much better than i found it
because of him.

i leaned over the bed
and took a breath from his open mouth.

i have never breathed the same way again.

live

do not hold on for a victory.

do not brace yourself for a tragedy.

forget the questions.

forget the answers.

do not wait.

do not wait any longer.

do not let the nature of time pass.

live.

extend your hand.

run to the tender feeling of love.

let chance and circumstance
happen upon you.

the songbirds will keep singing
their secret language—
that i am sure of.

and these songs are the symphonies
of my heart,
holy and unknowable
and pure odes to the honor of living.

love letter

i yearn to write you the longest
and most endearing love letter in literature.

my love remains down deep in your bones,
and each kiss is shadowed by every word i whisper to you.

please lend the night your luster,
for you are grander in your reticence,
and every one of your gestures is worth commemorating.

i am on the verge of tears
and laughter every day
because i am haunted by your face,
which i see in each star
and in each night sky.

stepping boldly
into the midst of everything,
shrinking from nothing,
my soul is fortified by the exposure
to your sunlight.

you are life's masterpiece,
and to be a part of this
brings nothing but moments of rapture
and deep quietude.

the essential,
poetic act of your nakedness
allows us to flow into each other
boundlessly and magnificently,
becoming the faculty
of our greatest joyfulness,
as you infinitely
remain the face of rarified love.

some questions

who, if i cried out, would hear me?

is it an act of cruelty to bring new life into this world?

do you choose closeness or distance, because both
have their consequences?

have i said enough in these books?

are we feeling the sadness our parents didn't have time for?

are there any hours left for vanishing?

is truth the simple act of getting through each day?

do we have the capacity for both anguish and contentment?

can we have honest and noble feelings again?

how do we continue to work and live in a culture
with no interest in privacy?

will the part of our glory also be the part of our downfall?

are the darkest places sometimes near the light?

has my heart been in the wrong place all along?

where is the space for pure vulnerability?

where is the human frailty?

perhaps when everything is finished,
that will be our beginning?

your songs

the beauty of your singing will bring us our ascension.
it is the gift of helping me hear what needs to be heard.

it is the only cure for the strain that wrings my heart
as morning breaks and i start the day without you.

what a vast
and open place
this life is with you in it.

my old heart still shudders with eternity
as i dream about you.

grace

walking these streets,
i feel the echoes of public spaces.

i glimpse strangers
and gaze at shop windows,
overhearing parts of passing conversations.

i also see familiar faces,
like earth coming back to life
after a hard winter.

this reassuring sameness
is something worth noting
and remembering.

continuing, i find the tears
slowly gathering in my eyes,
but i keep them down,
focusing on the bare beauty
of the somber sky
and its ancient holiness
among all these remembrances.

a little more each day.

feeling older and wearier
at this distance in time.

how do i resolve this burden
when the emotions are deep,
but the words are few?

i know life happens in the spaces
between happiness and heartbreak.

having it all hold in place
and fall apart at the same time
is precisely where the grace resides.

we still have today.

and i still have you
as my lover to behold.

equal

the
pain
of
losing
you

is
equal
to

the
wonder
of
loving
you.

some things i don't like

lawyers,
politicians,
parades,
pantyhose—especially white ones,
rhyming poetry,
most actors i've met,
most models i've met,
the oscars, the grammy's, the tony's,
and all similar award shows preening
and choosing "winners,"
the filming of movies on new york city streets,
high heels,
makeup,
hair dyeing (all men, some women),
dmv offices,
parking tickets,
critics (especially of books, movies, art, and restaurants),
calling people "chief" instead of their actual names,
calling dentists doctors,
potholes,
loud cars and loud trucks,
music from loud cars and loud trucks,
honking the horn as soon as the light turns green,
on-boarding planes and de-boarding planes,
influencers and social media,
selfies,
labels on clothes,
the sound of helicopters over central park,
grown men in spandex speeding on their bikes through the city,
grown men who wear shorts or hats to dinner,
people who like dogs more than children,
and of course: dog shoes and dog strollers,
and the allowing of dogs to pee and poop on city sidewalks,
bellybutton rings,
most tattoos,
professional sports,
the olympics,
the world cup,
the united nations,

socialites and debutantes,
vip rooms and most country clubs,
people who bump into you and don't say excuse me,
people you hold the door for who don't say thank you,
people you let in front of you when driving without
a thank-you wave,
the cable tv bill,
the restaurant opening,
the movie premiere,
apple's app refund policy and their products that die out after
2 years—a business model that enriches the few at the expense of the masses,
facebook, twitter, instagram, linkedin,
and their founders,
and their followers, including me,
the job title,
the job description,
the ambitious ones with the fake smiles and false praise,
people who call themselves "artists,"
people who call themselves "victims,"
people who describe their life as a "journey" and a "narrative,"
people who talk about the weather and traffic,
people who use the word "leaders" or "senior leadership,"
cigar smokers,
scotch drinkers,
bouncers,
bodyguards,
paparazzi,
gossip columnists,
press secretaries,
the nightly news,
the daytime news,
all religion,
humming,
whistling,
out of office messages,
and of course,
rude and unkind people in general,
which unfortunately,
consists of just about everyone in new york city,
the city i still live in and struggle daily to love.

prayer

in this prayer
we are lovers in the night
wrapped tightly
in our final act of compassion.

every embrace
serving as our guide
with gentle modesty
and the faintest touch of tenderness.

each whispered word to one another
possesses a sacred dignity,
allowing us to sleep soundly
in this divine heaven.

the sweetness of life

the divisiveness that seems to exist everywhere
the shocking lack of compassion
the anger toward each other
the unrelenting wars
the mass shootings of schoolchildren
the continued violence against women
the despair of this planet.

the architecture of values has been altered,
all met with a deadly silence
by the so-called "people in charge"
unable to care,
unwilling to be kind.

the indifference of history
will be their legacy.

our society believes
in the make-believe.
the glossed over,
the untrue,
the coldness,
the television series,
the blockbuster films,
the newspapers smeared with ink,
the hollow radio voices,
the me only.

conversations continue in a city
deaf to concern and

exhausted by the selfish expectations
of the majority.

living in an era
of unprecedented acceleration,

words don't seem to matter anymore.

certainly not poetry.

don't they know that poetry's meaning is in her words
and in the silence that surrounds each line?

but hopefully some of these words will survive.
maybe they will go against the grain of time

since each word comes from nature,
and each word goes through nature.

lives unfold
as storytellers young and old
gather to tell each other
who they are and what they are.

how we love and what we love.

how we live and what we live on.

how the world is made
and what the world is made of,
which is art and love and hope.

watching the sun stretch,
we must bear it all because
paintings won't stop the missiles.
music won't stop the sickness.
poems won't heal the broken bones.

no matter how much striving we do,
we cannot bend life to our will,
but we can avoid the self-obsessed.

we can look past the greedy ones.

we can say no to professions
linked to physical appearance
and financial metrics.

when faced with the possibility of an early death,
it makes you realize that life is worth living.

the search can end now because
you found the light in me i couldn't find.

we are each indispensable to one other,
but no one wants to believe it.

we live through this unknowable plan,
but our first step is to join humankind,
and let nature heal all of our wounds.

there is no disgrace that nature cannot repair.

look at the stars, walk through the trees,
watch the birds, squint at the sunlight,
sigh at the moon, sink your feet into the sand,
sit on the warm rock, run across the grass,
feel the breeze, touch the soil...

and let me love you
through water,
and over stone,
around bone,
and under dust,

because together and apart,
we are the sweetness of life.

being a father

every mistake i make
and every hesitation i have
lies in the murmur and the sigh of my heart.

i feel a bit overwhelmed,
but i am burning with boundless love.

i know that
each laugh may be the last laugh,
each parting may be the last parting.

my access to grief
is unlimited now,
even though the resulting tears
bring a sort of privileged weeping
because i can't live without you.

i turn my attention to being a father.

being your dad is the supreme honor.

the untroubled
and heartbreaking words
spoken by you both,
my daughters,
always seem to come
unreservedly,
simple and sincere,
at just the right moment.

the profound fortune
to live as close
to a noble life
as possible
is now mine.

thank you, emma
and thank you, mia.

your eyes

in the bloom of youth
i always enjoyed being alone,
which brought me
time and solitude
to reach the many other stories of lost love.

and the shaded truth
about our instability,
with fissures and cracks underneath
threatening to bring it all tumbling down
at any moment.

what will remain?

how will we be remembered?

is this our epitaph?

are we the story that lingers like the sustained cry?

perhaps we need some bread and wine
and a plea for salvation.

through the anguish,
we can find happiness.

through the pain,
we can find delight.

through the cynicism,
we can find earnest sentiment.

and through it all,
i can find your eyes
that still make the future
seem within reach
in a way nothing else can.

privacy

my life inhabits a private sphere,
but not an isolated one.

i don't make myself readily available
to others outside my family.

i spend a lot of time
writing at home late at night.

i place the highest priority
on time spent with my daughters.

together these acts have created
a haven from the rest,
both heartwarming
and heartbreaking.

i still have the resolve
to gather what remains
as i walk to the art studio
filled with dried brushes,
rusty scrapers,
half-completed canvases,
old easels,
paint-splattered floor,
jars of soaking paint,
and i know that all will be redeemed.

the eternally elusive
expanse of time
and the boundless affection i feel
compels me to keep my face
to the sun
as our meaning is beyond
the reach of words.

still left to be lost

i glance at your face,
lit for a brief moment
by the moon,
and see all that is
still left to be lost.

you are amplified in the silence,
and even your reflection aches my heart.

the delicacy of your existence
and the possibility of love,
set down with due care,
as we are still willing
to hold each other's truth
with tenderness
and let our great
love story continue.

pure

some things are so pure
they can never be sold.

for you

i know the years will pass through
with love at my feet,
changing the shape of time.

i know there are words i can never explain,
but i have another song to sing for you.

i have another poem to write for you.

after all this time
and the warm tears
across my face,
there is still you
and all that remains.

dare i imagine
some faith and understanding?

dare i imagine holding you close
to save me from the shadows?

i still need water.
i still need air.

you came to me again in a dream
just the other night
and it occupied
more than half my heart.

i've done what i can,
the best that i can.

and this is my awakened sense
and the gasping recognition
of what it is to be alive.

despite my broken heart

how do i live this life
where everything moves me,
where everything i hold is dear?

my love for you,
unaltered by time and memory,
inviting me to reflect
on who i am
and what i am,
reminding me
of the capacity for beauty
and transcendence.

you alone
stopped me from blinking,
and your light remains ever present.

there is nobody else like you.

crushed by the pain of what will come,
i will hold you close
with all the magic and mercy i can.

every day i wonder
is each laugh the last?
is each embrace the final hold?

let me reach across the bed
and wrap my arms around you.

i give you my soul,
despite my broken heart.

59 stars plus 1 moon and 1 large star
(october 8, 2022)

59 stars counted
in the eternal night sky
plus one full moon
and one large shining star to her left.

nature's living work of art,
our stunning testament to life,
and one of the great blessings of being human.

there are an estimated
100 billion galaxies
in the universe,
home to an unimaginable
abundance of planets,
yet this is our illuminating world
on this saturday, treetop night
at 11:58 p.m.,
with all so far and all so near.

i see the shadows that we cast,
but they will not melt the light.

the soft shining from your eyes
and kisses that remain infinite.

this is ours alone tonight,
as everyone else sleeps soundly in their beds,
in a home surrounded by nature,
a garden still bursting with life.

this is not a lonely night.

there is nothing more than this moment.

forgetting this life,
and remembering this life,

we shelter here tonight,
and all nights to come
until the end of our days.

seeing your face
will always be glorious
and everlasting.

it will unburden
any lingering sadness,
turn fear into hope,
questions into answers.

i want to live a long time now.
to see this.
to see you.

our tears sweep the sky
and dim the stars.

rare is our every day.

time courses through me,
aware that everything will disappear.

life is always lost to time,
and most don't even realize it.

centuries of gestures will be forgotten,
but our existence is the triumph.

this is the most unknown
and wondrous thing,
the most exalted days of our life.

this is our radiant portrait,
on a day that started with a young man
having an epileptic seizure
on the corner of main street.

not knowing what it all meant,

we rushed to help,
gently placing my youngest daughter's
lavender blanket under his head,
with warm hands we rub his back
while turning him on his side
until the shaking stopped
and he fell asleep
as the ambulance and police arrived.

my daughters cry a little
out of fear and the unknown,
but looking up at the 11 a.m. sky,
they see the morning moon
still showing her face,
to be further revealed
to us later that night.

it was indeed
a pure, magical day
full of glory
that was not lost on us
and never will be.

a heart

love
never
leaves
a
heart
where
it
found
it.

the candle

i know that everyone says goodbye
in their own way.

i know
at some point
all of us
will lose everything we love,

but something lets me remain
open to the finding...

and it's in this finding
that lost things may return,
in one way or another,
and bring simple delight.

i remain a child
with eyes wide to see all that is always new.

i remain a child
with a young heart, choosing to still believe in love,
enraptured from the inside, encased from the outside.

will this bring desolation and bereavement
or will this bring awe and wonder?

this is all i have,
this moment with the world.

i am held to the earth.
i resist falling.
i make space for the improbable
and fold it into my life somehow,
along with the presence of their absence.

i look at you again
and you are still the candle
i don't ever have to light.

love

my parents gave me many things,
but the idea of love was the one.

i can only hope
my two young daughters
recognize love
because they have seen it
from their earliest days
poured into them
with endurance and persistence,
forgiveness and understanding.

our defeated marriage,
one of the most nakedly emotional moments,
is one that still leaves me haunted,
but our friendship
is one that leaves me hopeful.

with clasped hands
in front of a wounded earth,
i think of us as ancient trees,
certain and strong enough
to survive it all.

the frayed edges of sorrow
will always be felt,
filled with the expanse
of lost moments
and living memory.

every occasion without you two
is a reminder of what to believe in
and what should be paid attention to.

i walk when i'm alone
through these old streets
of long city days and nights
that wrap around themselves,

sparking new tears at every turn.

pray for me
that i am still capable
of acts of kindness in old age.

pray for me
that i always remember
that being your father
and loving you two
is the most wondrous
and supreme gift
of my life.

by the sea

we kissed by the sea for the very first time,
and so we were celebrated by nature and the gods.

luck was on our side
and then it wasn't.

i loved you then
and i love you now,

i will love you until the end of time.

there will be

there will be stargazing and music

hearts that break too soon

the benevolence of nature

the victory of beauty over brutality

your eyes that look different under the moon
than they do under the sun

the importance of noticing
and the respectful attention
one brings to bear upon the world

fortitude given to face the frightened feelings

grand gestures of the restless soul

the poetry of possibility

the waiting for a gentle touch

the goodness and the kindness

the preservation of hope in even the most desperate
and unspeakable of circumstances

the immeasurable truth of life's dedication

and your gift to the world
because the fact that you exist at all
is simply our miracle.

the sweetness of life

in spite of it all,
we still believe
there is graciousness
in this world
and that the pain will be
outweighed by the tender moments.

maybe we can live
honorable and generous lives
and extinguish the light on own terms.

these cityscapes may turn to dust,
but our human truths will be unveiled,
radiating eternal ideas about the meaning of life.

where is our place in this universe?

who will magnify the magic?

who will understand what it is to be human,
to celebrate life,
to fall in love with all of it,
even the parts not noticed
and yet to be named?

we are all going to encounter
illness, loss, and aging.

i walk out to the backyard
into the dark night
and look to the moon.

i know we can live
and sleep in peace
because, despite it all,
the sweetness of life
somehow remains.

talk to me

what upholds also gives way.
who caresses also lets go.

the heart falters
and the body is quieted.

stars burn out
and atoms disintegrate.

talk to me
about how we uncover the lives
of those we love.

talk to me
about the measure of a good life.

talk to me
from the distant past long before i was born
to the distant future long after i die,

because you are the bright gift of chance
and the delicate emblem of love.

emma and mia into the bed
(12/14/2022, 2:07am)

emma comes into my bedroom,
wakes me up, and
says:

> *"daddy, can i sleep next to you?"*

> *"of course you can, emma."*

emma climbs in on the right side
and turns so her back is facing me,
i put my arms around her arms,
and she tucks her feet under my feet
and says:

> *"i'm cold, daddy,
> thank you for keeping me warm."*

> *"i love you, emma."*

> *"i love you too, daddy."*

next, mia comes into the room,
on my left side,
and she climbs into the bed
without saying a word.

she reaches for my hand
and entwines her fingers
in between my fingers
and falls fast asleep.

i whisper:

> *"i love you, mia."*

i lie there staring
partly at the evening sky out the window

and partly at the christmas lights
from the building across the courtyard.

all is quiet
as the immensity of this moment
overwhelms life itself.

for the first time
i fear getting older.

stay with me.
keep with me.

don't let morning come.

i can't find the words,
so these delicate and triumphal tears
will have to do.

i never expected
such a large and possible love.

my stories with you
are what shape my life.

with hope,
these stories will echo
across generations
and more richly
through the upcoming years.

this is the moment
i say yes to life
and everything holds.

yours are the hands
that always belong in mine.

i hope i gave you a chance to love
and a place to rest.

the great reward of love

the eternal task of love,
our human gift and privilege,
continues as trees turn to soil
and shells turn to sand.

i still hear apollo telling me to be brave.
i still hear aphrodite telling me to fall in love.

we have the capacity for hope
and the magic of humanity.

all love is a form of hope.

i ask you
not to let go
and to maintain your faith in all we have.

the preciousness of life
will stay with us until our last days,
and this will be the great reward of love.

the end

search for truth,
for meaning,
for a way of life
to see clearly our human fragility
and the haunting awareness
of the absence that will eventually arrive.

our love, our life,
the sun, the moon,
the planets.

the best way to see
how beautiful this all can be
is to view it from the other side.

before you return
your stardust to the universe,
fall in love with these moments
that scatter the stars in the sky.

remember,
always remember
that even dying stars,
release energy into space
and are capable
of warming orbiting planets
with their finite breath.

sacrifice
(for emma and mia)

with every cell
that turns my body into being,
i am here with you,
my little ones.

your stunning and sweeping
generosity of spirit
becomes the most intimate meaning of home
and the radiating reminder of pure universal love.

i search for courage
through these words
because what i write for you matters.

i even count the seconds
between our breaths sometimes
and let it become the timeless resonance
of all that is alive.

i hold this glimpse into the day ahead
and will sacrifice all i have for you
and for these moments.

the moon

all i am doing
is attempting to survive my time
so that i may live in yours.

you are everything that moves me,
everything i hold close.

i stand here before you
with my hands across the centuries
and arms outstretched through the stars.

you are my not-so-secret place
full of amazement.

you have the unspoken divinity
of my human heart.

you are the center of everything
i believe in through love and care
that springs from the purest of places.

you are the constant reminder
of our endless human capacity for love.

every time i walk outside
and look up to the night sky,
i can greet the moon with hope
because of you.

and i can speak to something
in my soul
that has been awakened.

passing

i miss you
until i close
both of my eyes...

the poetry of life

the enduring fidelity to the astonishment of life,
to the gestures of small flowers
in this rare hour.

of you here
and me here,
leaving a lasting mark on humanity
and an illumination on all that has ever been.

a reflective moment
unaltered by remembrance and memory
felt on the edges of delicacy,
everything that moves us,
everything we hold dear.

a sacred fire,
hearts beating in unison,
eyes in harmony,
invitations to accept
who we are
and what we are,

in our time,
in all time.

it is the poetry of life.

love

we may connect better
with the setting sun,
but dawn is the beginning.

the sacred time.

the holy time.

the gentle following of a specific night.

the minutes of the day begin,
the weight settles on you,
the sadness may pull down
your shoulders a little,
but it's ok.

there will be
meaning from discord,
elation from despondency.

let the bewilderment of beauty
among the trees
be your unassailable delight
in the face of any
struggles of existence.

it is these mornings that wake us
as silent witnesses to the human heart,
serving as the eternal testament
to something intimate and immediate
that makes us a bit more alive
and confirms that the only point of life
is love.

always

it's the smallest of moments

the echo, not the first words

life under the spell of solitude

memories that exist
outside the beating minutes of time

the world as broken
as the people who populate it

growing tired of all the things
the young and ambitious ones aspire to

the dishonor of fame and attention seekers
destroying human connection

the defiant disdain for our culture's
worship of celebrity, beauty, and status

the tranquility
of hymns sung in the rain

the belief in and celebration of
the uncertain light of evening

your words that give my heart
the instructions for survival

the openness of unbroken fields
under the rising sun

not letting the miracle of life
recede each year

not allowing the splendor of time
to elude us each hour

knowing that hope is the thing
that stands alone under these defiant tears

the unsung kindness of children
stitched through the thread of life.

the moments of startling resonance

the efforts of lovers slowly rebuilding their lives

the sense of waiting for something that never comes

the braveness of parenting and motherly affection

the chance-miracle of our time together

letting us recognize other poets just by the look in their eyes

my voice that you hear, so you can speak

my heartbreak that you see, so you can feel

my joy that you reach, so you can celebrate

my failure that you witness, so you can allow it

my endurance that you know, so you can make up the distance

the fleeting beauty of a world
where one could be swept away in an instant

realizing that not even for a moment do things ever stand still

that sooner or later, the terrible thing will happen

the gentle way to encounter the hardest truth
that everything ends

the grace to grieve in a way you thought unimaginable

that suffering is not an illness with a cure

not letting my failing body become a burden

letting everything slow down
to illuminate the particular details

the casting of a glittering light
on the rest of what remains

to wake before dawn to watch the sunrise
and take a few moments to listen to the birdsong

the beauty of others all around us,
if you know where to look

capturing your last breath

before becoming a dying star,
collapsing into a black hole

and it's that precise hour
that is always certain to come,
so forgive as graciously as possible

and wrap your arms around
the exuberance
in the art of living.

the richness of life

i love you, emma and mia,
and that makes me
in love with this world.

you need to know
that i have not wasted
one minute of my life
since your birth,
and it will be very difficult
to leave it all behind.

we know the ending
of every human story,
our breathtaking finality.

haltingly,
tearfully,
love and despair
walk hand in hand
through our world together.

how remarkable it is
that we are here
in this time,
in this moment,
in this life,
full of grace and gratitude.

let us linger in this grace,
let us linger in this gratitude,
cherishing our privacy and our quietness.

your simple kindness is the largest truth
that expands and becomes the calibration
of life and love.

the world certainly doesn't deserve you,
that's for sure,

but you have vanquished all of my fears,
and tomorrow i will stretch out my arms
as wide as possible
around the richness
of this life you gave me.

triumph

we are more fragile now,
more connected.

this is our shared lifetime,
not just a moment.

this is our loving poem,
our hymn to mankind,
our prayer to humanity.

day flowering
night blooming

recalibrated
revitalized

awaiting a gentle touch,
lifting our heavy eyelids

the world will
never live up to the romance,
but we will...

and we will do so
in the comfort of our closeness,
singing the arias of our soul,
as our story's heart skips a beat
and our existence together
becomes life's only ceremony.

our little garden
(may, 2023)

moment by moment
one beautiful thing at a time.

we can take care of each other,
but we need to see the
expressions across our faces.

we can understand each other,
but we need to hear everything in our voices.

radiance takes time,
like our little garden.

with hands
smelling like the earth,
kneeling before these seeds
under these stars and
the half-moon in daylight.

did i mention
the doves,
the cardinals,
the bluebirds,
the hummingbirds,
all hovering nearby,
shimmering with enlightenment,

giving us their lovely gestures,
living fully into the grandest of existence?

this is our invitation to presence,
our remembrance of it.

let's be a little more attentive,
a little more appreciative,
a little more beholden.

let's take tonight
and hold it tightly.

and let's wrap our arms around
our blooming humanity.

life

war and other horrors,
a global pandemic,
millions lost in two years,
random stabbings,
people thrown in front of subways,
children killed by deliberate bullets,

the wails of a broken heart,
despondence everywhere.

the language of loss and mourning
catching up to the history of human sorrow.

wounds that cannot be healed.

sitting quietly,
weeping,
piercingly overwhelmed
and for good reason.

given a world ever needful of tenderness
as cliffs collapse,
dams break,
earth gives way,
oceans rise.

with hopeful gestures,
we still laugh,
love greatly,
and somehow remain
adoring of our every teardrop.

from the heart

how do we live more nobly now
in these uncertain times
that blindside us with beauty
and brutality in equal measure?

where do we find the kindest of human beings?

when do we consider the merits of sensitivity?

do we truly reflect on the continued loss of life?

run your fingers over the scars
that were once wounds and have healed.
what do you feel?

all of life's cycles define time,
but here time could not be made to stand still.

i lie in bed beside my 10 and 8-year-old daughters,
and the smell of their hair makes me weep.

this is my late-night splendor,
the only way to spend the end of my days.

my heart and memory
swelling with every tear.

keep us tired,
but serene.

these anguished poems
documenting how we live and love,
in a world becoming ever unworlded
with discontinuous affections.

thankfully,
writing is a silent art,

but i need you
to give me a moment to speak:

"please live from the heart..."

that's all.

childhood

sometimes you come across a day
and it's everything.

it makes you believe
this life is sacred
and probably even a little enchanted.

the grass stains on the knees,
missing front teeth,
legs covered in bruises,
warm strawberries from the garden,
melting ice cream,
flushed faces,
and time stretched out before us.

i cry and laugh
but find myself
in muted awe
and aglow with admiration
at the imperfection and perfection
of these portals of beauty.

it is the blueprint of our immortality.

i don't want to ever say goodbye

in my every encounter with you
i am saying goodbye,
so i am trying to do things
every day that are unforgettable.

i will deal with all of your needs first.

i will hold your hearts with both hands.

i hope you know that the candles burning,
flickering in the night,
are only for you.

i am searching for the eternity
of the human experience.

it leaves me
tender and terrified,
ecstatic and ephemeral.

the fragile lament
arrives with the long rhythms of the sea.

it is your unresistant presence
that allows me to seek a good and meaningful life.

i can only hope it inspires someone
to a few daily acts of generosity
so our lives are a little more livable and luminous.

goodnight

soft and asleep
after my goodnight kiss
on your forehead
and a rub of your back,
your blanket will keep you warm now
together in the dark
after turning off the lights.

the reflecting heart
in the stillness of silence.

the quiet magnificence
of sleep will bring you tomorrow.

and tomorrow is a new day
to do with it what you will.

it is the days that make the threads
of which we weave a life out of fascination.

i will stay deeply embedded
in my love for you
and for our family
in the most intimate of ways.

i will keep
a state of reverence that is your beauty
and devotion that is your generosity.

our entire life,
daily and monumental,
will be one of the innumerable glories of love.

i will never abandon you.

i actually burst into tears
at the very thought of you.

i will remain the hand

reaching for some of the light
that lives between us.

i'll meet you in the flowers
and cry 1000 tears of happiness loving you.

the stars are our revelation.
the sunset has no equal other than you.

my daughters,
my sweet little ones,
trusting everything,
looking for magical places,
and always finding me waiting for you.

i'll always wait for you.

i'll always be here.

i don't want to leave

the life you have given me
is one that i don't want to end.

i am haunted
by the running out of time,
which everyone else
seems to effortlessly ignore.

i have always let this gently guide
my beliefs and my behavior,

appreciating every moment,
crying every time i said
goodbye to my parents,
knowing any minute could be the last.

even now,
i cry every morning,
and i couldn't understand why.
i thought it was depression
or over sensitivity at first,
until i realized it was just
saying goodbye for the day to my daughters.

the year 2020
brought death closer
to the rest of the universe,
to the one's suppressing it,
it made death louder;
it made death real.

most of us don't arrive there
until we've lived more days
than we have in front of us,
but i always felt
the presence of it...
always knew time was finite.

from the very beginning,
i understood how limited it all was.

reality is a thing
of unrelenting danger.

i knew this
and never screened out the signs.

i became vigilant,
seeing everyday life differently,
hearing the words differently,
touching differently.

i am not spared one minute.

when my father died
on october 28, 2020,
i lost the one person
i always knew loved me
more than anything.

the absoluteness
and proximity had arrived.

it feels shocking to me
that everyone's parents die.

it's shocking that it happens at all.

why aren't we talking about this more often?

i realize that it is
something more than grief.

it is nameless.

i feel its seriousness.

its weight.

it's my complete love
that i bestow on my children.

the love i have for you
will outlive me
and will always be there
as my remains are laid to rest.

you kept a steady hand
and a helpful heart.

it is the sweetness of your skin.

it is the hope of impossible things.

i wish these days would never end.

i wish the sun would continue to fill the sky.

in my mind, you are as vibrant
as the last day i saw you,
and you are always in my dreams...

i even dreamt about you last night.

my own memories
fuse into a map of my youth.

we are lives harnessed together
until one of us has to leave.

it is the importance of daily life
and the ordinary moments.

it is the extraordinary bewilderment
of things...
sacred, vital, and resonant.

every moment is an opportunity

to be present.

to be unbearably tender.

celebrate life,
filled with purpose and jubilance
and mistakes and failures.

celebrate life,
with a profound kindness
to everything that exists,

and celebrate life
and all we have
in their honor.

the puzzle

i'm holding on
to the part that i'm losing.

but beneath the sound of promise,
there is the calling of our hearts
to open with splendor.

calibrating the love and losses,
knowing the light always fades too soon,
holding a boundless view of the world,
with no beginning and no ending.

no matter how much striving we do,
we cannot bend life to our will.

my hands will continue
holding on to what is already gone.

where will my bones rest?
i ask to no one in particular.

the love i hold for you
is felt farther than any star
and will be our deepest source of communion,
awash with something we cannot name.

i hold on,
knowing all my secrets
are in your heart
and that every feeling
i tremble with,
you already know.

i have conversations with people
deaf to silence.

i am exhausted by the expectations
of the majority.

we lose everything
to death,
to distance,
to differences.

but we gain everything
by watching our children
piece together the puzzle of being,

disregarding time and resting
with a wakefulness
to all of life.

our time

this miracle of chance
where we get to experience
this sky,
this ocean,
this soil,
this sand,
these trees,
these birds,
our families,
our loves,
all rooted in a state of
wistfulness and longing.

dividing our days
between what we have
and what we no longer have.

after the sun sets,
and everyone goes home,
it will be just us.

always, just us.

here i am,
and here you are.

our collision with chance
is the promise of rest and dreams,
and the offer of eternal togetherness.

some more advice

forget the
celebrity sightings,
the tabloid gossip,
and the news media.

remember that the assassinations
of martin luther king,
john kennedy,
and mahatma gandhi,
and september 11th
speak volumes about our world.

sitting at a desk
for 40 hours a week, staring at screens,
is not how humans were intended to spend
their waking hours,
and perhaps no one should be that devoted to work
that easily erodes your sense of self anyway.

the powerful will do whatever it takes
to stay as they are,
and the weak will suffer what they must.

self-exposure is never the most important aspect.
discretion should never become disclosure.
keep a private life, not a public one.

talent and quality usually go ignored,
and when and if it ever gets recognition,
even that is through happenstance.

be more occupied with
saying the right thing
than saying something well.

dreams are more loyal than most people.

over diagnosing and over medicating

have become fundamental aspects
of the human experience;
disregard them.

you can denounce luxury
as long as you don't covet it.

the hyped and overexposed,
the flashy and the false,
the reinvented and the reformulated,
are all hiding something broken;
don't waste your time trying to fix it.

disregard the constant appetite for the new.

celebrities, like all politicians,
have that undeniable mix
of insecurity and arrogance;
forget them also.

follow your otherness.
show your scars
your failures
your distortions;
they are beautiful.

master the art of being you.

don't try to unmake the life you already lived.

be open to the wounds and the bounty of life.

explore like it's the last time
you will have good vision.

let your existence be your poem.

you are what you love.

wrap your arms around the magical space of light.

give a hug that stops time.

stay indifferent toward attention.

work without applause.

there is no performance you must achieve.

there is no distance you need to reach.

and never be uncertain of what love looks like.

stay enchanted by the possible.

be boundlessly courageous.

hold on to the thought
that our earth tilts toward the sun
and that same sun rises early,
climbing high into the clouds,
sweeping above city skylines
and mountain peaks.

that should be your reminder
that living is the here and now.

say all the words
that burn the back of your throat
and sear your heart.

you are no more human
and no less.

it's just the delicacies of existence,
and you are the living monuments of life.

78.7
(2022)

the average age of death is 78.7 years.
78 is not a big number.

i am 53, so if i'm lucky,
i have 25 years left.

that's it.
25 more summers.
that's not a lot.

it's just time sweeping through.

the art of being lost is now mine.

living well past the midpoint
of my expected lifetime,
i am still longing
for a truth much larger
and longer lasting than myself.

i will enjoy the slowness of nights
as the moon casts her long shadow over us,
tended now with supreme care and love.

i know there are handwritten love letters
waiting to be sent.

i know my dreams don't remember that you're gone
because i still find you here.

i see you every day.

i will remember the ice cream running down your fingers
and us walking under the sun unclouded.

you are what will always make life worth living.

today, we are glistening.

and today gives meaning to our existence.

my eyes now see what it didn't see before.

we are the living flower

the single stone

the standing tree

the finished day

the coming night

the only existence.

we are the secret promise of life
and the simple poetry of love.

childhood

my
endless
faith
in
humanity
rests
on
the
eternal
sweetness
of
my
childhood.

for you both

the days when i have
nothing and everything to do,
i silently serenade the ones i love
with a poet's reverence.

i hope you know
that our moments together
fill me with all of life's affection.

the yearning for these fragments of life
are found in you.

i know how deeply
we are imprinted by our early experiences,
and i will continue to give you everything i have.

i will walk miles to see you if only for a minute,
a minute that can bring weeping for hours.

i am all the days you choose to live.

together,
we are like birds accumulating twigs for a nest.

when i'm not with you,
it is the never-ending heartbreak of farewell.

every day i begin again,
one foot in front of the other,
with an endless view of beauty
as we bathe in the glow of the sun,
setting late into the evening.

with no beginning and no end,
i want to live a life worthy
of your every breath.

these words, this life

this delicate work.

this devoted work.

trying to leave more than faint traces
of myself as a person.

what will be my remembrance?

will there be any radiance left behind?

will you see the celebration of life?

was there a contribution to understanding each other?

did you see the sentiment?

did you feel any rapture?

was there effortless kindness?

did you discover a guiding sun?

will you see the willingness to do whatever it takes?

the search for moral beauty?

the effort?

the integrity?

the weight of possibility?

the purpose and the meaning?

the string of days that was our life?

the strength of surrender?

and the never-ending search for the ones
whose character has been shaped by
poets, painters, musicians,
artists, physicians, nurses,
florists, and astronauts.

our beginning

arms collapsed,
walking straight through,

plead for me;
pray for me.

always running out of time
with this individual human life.

let it unfold.
let it keep burning.

when bones turn to dust,
i stand on the side of love.

uncertain where to begin.
uncertain when to start again.

here it is,
right in front of you:

these woods,
these birds,

this ocean,
this sand,

as spectacular as anything.

always on the verge of tears

the realm of smallness,
the bewilderment of what's coming

our despairing humanity
always in need of care and mercy.

please offer yourself

a loving hand of friendship,
because all love will endure
as long as life lasts.

remember how life started
some 2 billion years ago...

the particles, the gravity,
the energy, the stars, the planets

the thinking and breathing

the living and wondering

the harrowing beauty and brevity.

we are all the same;

our souls are entitled to find refuge.

we owe our beginning
all the graciousness possible
in this loving and luminous life of ours.

the sunflower or the sun

i hear the low hum of heartbreak,
diminished and disowned,
as the end approaches.

i'm holding on
to the part that i'm losing,
even though the day
rises slowly,
beneath the sound of hope,
calling our hearts
to open with adoration.

i ask myself,
was it the sunflower or the sun?

or was it just
the poetry of existence?

these verses of life?

these extraordinary emotions?

the exquisite monastery of feelings?

or was it just
the spell of this moment
in a life unimaginable
without the person you love.

close your eyes

to see love,
it's sometimes better
to close your eyes.

the same eyes
that will, in turn, close one day
when you least expect it.

hold on to the weight of possibility
among those unready for your words.

create on your own terms.

in this
you will find
an echo of meaning,
a glimpse of the unknown,
and gentle moments
that make life worth living.

come live with me
in this house of solitude
with uncommon beauty,
welcoming starlight each night.

at the heart of all this
are simple human expressions
and the smallest gestures of kindness
bringing nothing less than salvation
among the symphony of life.

granting care to the sick.
smiling at strangers.
living out your dreams in great measure.

i'll say it again: time and love is all we have.

prepare yourself

for any sudden and inexplicable absences.

keep holding on to what is already gone.

we need courage to be bound by love,
and we need the same courage
when it slips away.

live with simplicity and warmth
and be incredibly tender
with the arrival into life
and the departure into the unknown.

make life brighter
and more livable
for anyone in your presence.

share the secrets of your heart,
for every feeling you shudder with,
you shudder alongside another.

hold your love's heart.

keep it still,
if only for a moment.

thank you

little ones,
you witnessed
our greatest failure
and love us anyway.

1,000 ways back

my 7-year-old
daughter mia
turns to me and says:

> *"daddy,*
> *i love you*
> *to 1,000 moons,*
> *and to 1,000 stars,*
> *and to 1,000 ways back."*

i realize
that each hour with her
and her sister emma
is a work of art in and of itself,

and the love i have for them
will always be my greatest living poem.

all flowers, in time, bend toward the sun

reach for tenderness,
and in this place
you will find that time
is incomparable in its reverence.

but to reach this
requires plunging straight into
the heart of bravery.

this is the only way the moments are arrested
so you will have a decent chance
to find solace in the privilege of living
and loving full of resolution.

the radiant majesty
of the glimmering sky
after sunrise
is equaled
only by
the love between us
as we watch this all unfold.

and as you do,
you will remember
that all flowers,
in time,
bend toward the sun.

task
(for emma and mia)

your task
is to learn how to live a life.

you will have heartache and pain,
but you will also have hope and love.

you will never be alone
in caring for your life as long as i'm here.

life comes with the intrusion of death,
but let that illuminate you and not bring you fearfulness.

the universe is smaller than you think, once you get out there.

ask questions.

keep your dreams close.

take photographs of the simple moments.

share a meal with the one sitting alone.

lose your way, get lost, and be found again.

welcome the rain when it comes.

remember the ladybug on your fingertip,
climbing the oak tree,
listening to your dad read bedtime stories,
finding your way to your mom's bed,
running to grandma and grandpa off the plane,
playing music with your uncle,
planting marigold seeds in the garden,
visiting the beach,
finding shells,
collecting stones,
gathering feathers,

swimming in the ocean,
finishing puzzles,
exploring central park,
playing school,
going for ice cream and gelato,
riding scooters,
riding bikes,
riding atvs,
feeding ducks,
saving injured birds,
drawing and painting in the studio,
eating popcorn in bed,
eating dinner in bed,
watching movies,
making cooking videos,
playdates and playgrounds,
petting every dog we pass on the street,
bouncing on the bed,
singing in the car,
watching sunsets,
dancing to every song,
chasing the moon,
catching fireflies,
leaving food for the deer,
creating our garden,
lying on the ground and staring at the stars,
riding the jeep over the bumps,
going to carnivals,
sleigh riding,
ice skating,
hide and seek,
the waterparks,
the rollercoasters,
toasting marshmallows,
swimming at night in the pool...

don't worry too much;
there is a ray of light in every crack.

the green trees will always rise in the distance.

you will always have a home
filled with tenderness
and sleepy afternoons whenever you want them.

remember that all the blue in the sky is for you,
and all the love in my heart too.

remember there is delicacy in each step,
each bite,
each breath,
each touch,
each glance,

each embrace,
and each kiss.

all of these details,
all of this life,
is yours.

please remember
that my time with you
has been the happiest of my life.

have a generous heart.
keep a dignified manner.

laugh as loud as you want.
cry as hard as you need.

do you see them?
the ones with all the answers,
the ambitious ones,
always unfulfilled,
preening, posing, and searching.

they think nothing has the right to exist
unless it makes a profit or benefits them only,
which renders their opinions worthless.
forget them all. every single one of them.

walk ahead.

risk the discomfort of real empathy.

don't chase the perfect moment, just capture it.

the time that passes counts; don't let it go.

don't become enraptured by what you buy
and what you spend.

go with strength without belligerence,
loyalty without question.

courtesy and manners
are dual expressions of hope.

look for faces that are beautifully plain
and plainly beautiful.

stay connected to the lessons of your past.

keep your eyes open
to the realities of the moment,
to this hour,
this cup of coffee,
this glass of wine,
this conversation,
the warm back next to you.

don't hide your kindheartedness.

time heals nothing.

turn traumas into definition and urgency.

fracture and fail often.

there is meaning to it all.

keep it personal and keep it private.

stay original and uncompromising.

have a poetic and heroically human touch
with everyone you like and love.

let evening come,
for it is night when your day is won.

move through the seasons of change,
floating across landscapes of possibility.

arrive burning with the memory of emotion,
shining on the beauty of all things,
just like the two of you.

remember,
sticks and stones break your bones,
and words will break your heart.

sometimes these pains echo through the years,
but if you go far enough

you will always find love.

the highest and yet attainable human value
is still, and always will be, just that: love.

and my love,
burning and exclusive,
is only for you.

flowers

holland has her tulips
india has her lotus
japan has her cherry blossoms
england has her red rose
italy has her white lilies
china has her plum blossoms
france has her irises
hong kong has her orchids
belgium has her red poppies
barbados has her poincianas
cuba has her jasmine
denmark has her daisies
ethiopia has her calla lilies
ireland has her shamrocks
portugal has her lavender
sicily has her carnations
tahiti has her gardenias

and i have you...

eternity

on this particular day,
at this particular moment,
in the dawning years of our existence,
i see what was once unseeable,
and it pierces the veil of darkness.

take my hand,
whisper those sweet words to me,
let's lie together as one.

while we are sleeping safely
on the hope of miracles,
let's go back over the things we missed;
let's repair what was damaged.

we can grow larger
and more heroic
each day,
in size and scale,
and brighter in color.

ask me those unanswerable questions.

let's be still
as things come and go.

let's be silent
as hearts rise and fall.

let's live with intention
and the extravagance of expression.

let's tell stories
and share
the deepest parts of our lives.

let's listen
to the fragile notes
of our life.

the love felt
is tender,
and holy,
and always
our last act
of kindness.

the seams that bind us
will never unravel.

the sunset is beautiful
and ours alone tonight.

it is forever, as now.

my god...the weight of this universe.

and you.

otherness

do no harm,
the physician's guiding principle,
should be the universal way for all.

the more you give,
the more riches you will find in yourself.

remember, eyes and mouths can be sealed,
but our ears cannot,
so we have to listen to the vibrations
filling the space around us
with eloquence and sensitivity.

it is the consolation of living an honest life,
with the fullness of feeling
and the certitudes of raw emotions.

it is our invitation,
and our means of survival.

it is what enlivens us in the moment
to breathe life in with a magnitude
of thoughtful meditations
marking the beginning and the believing
of our small work.

it is our devotional act
in the most faithful way possible,
and it will take our breath away.

the scars will tell our story,
chronicling the past,
as we embrace the notion of success
as being only the privacy of the soul.

our sensitivity becomes transcendence,
an abandonment of the ego,
as we let nature unfold

the moment of time's passage,
welcoming the winds of change,
and the otherness that we will always feel.

remember me as a time of day

if we never meet again,
remember me...

and remember me as a time of day.

remember how my simple words were written for you.

how the pencil in my hand wrote for you.

how my heart melted for you.

it was always for you.

if we never meet again,
remember me...

and remember me as a time of day.

postscript

some words that helped ...

you
(My first poem, written at age 13)

You are yesterday,
Gone like the sun.

You are the memories,
Fading one by one.

You are today,
Here like the sky.

You are the dreams
I won't let die.

I have you today,
in the memory of yesterday.

I have you tomorrow,
In the hopes of today.

where i'm from
(A poem by Emma Silich, age 11, written June 2024)

I am from a stuffed animal named "cheekey",
from bunk beds to twin beds.

I am from staring into picture frames,
memories flowing back to my brain.

I am from blowing on dandelions,
always wishing for the same thing,
whose seed heads run away from me
while carrying wishes to the sky.

I am from a sunny summer family,
waves crashing replaying in my head,
swimming in the ocean,
getting out is always annoying.

I am from sand wiggling in my toes,
outdoor showers are always the best life saver.

From 9am-5pm always with my friends.

I am from sweet goodnight tucks
from daddy and mommy.

the silence in me
(A poem by Mia Silich, age 9, written June 2024)

The silence in me.

The warm colors in my eyes.

The beautiful sun.

The sound in me.

It makes me dance my heart away.

My dancing is free and beautiful.

I feel so calm and happy.

I smell the flowers, the pond,
and the fresh smell of the wind.

I feel the wet grass between my toes,
It is so ticklish.

I will always cherish
all the special memories I have made here.

It is all so special.

It is like my home.

Acknowledgements

Once again, I would like to thank my publisher, the Brooklyn Writers Press, and Marina Aris for publishing this 4th book of poems.

And again, Marina, thank you for your loyalty and trust, and of course, our over 25-year-friendship filled with kindness, tenderness, and understanding.

And for the words you sent me on February 6, 2024:

"Stephan, You have more to do and we have more to do together. These books of yours in some ways are both of our legacies. I am grateful for you. I am grateful for your talent. I am grateful that destiny has paved a new road and journey for us to venture on together. I am grateful for our history that is now more than two decades long. I hope these words make you feel loved and supported today. Love always, Marina."

I would like to thank my editor, Judi Heidel, for her always gentle touch, which has provided guidance and inspiration from the first book to this latest. I've agreed with every one of your suggestions and comments, which is a wonderful thing to find in an Editor. Thank you, Judi.

I would like to also thank:

My beautiful daughters, Emma and Mia. I love you more than anything in this world. Thank you for giving a meaning to my life I couldn't possibly have ever dreamt of.

And Emma, thank you for the words you sent me on June 16, 2019 on Father's Day:

"Dear Daddy. Happy Father's Day. I love you so much. I hope you have a good day. You are the best. Your salad is so good. I really appreciate what you do for us. Thank you so much for the amazing bedroom. Thank you for letting us jump on your bed and sleep in your bed when we want to snuggle. I love our movie nights. I love you. I hope you love this card. Love, Emma."

And Mia, thank you for the words you sent me on Christmas, December 25, 2023:

"Dear Dad, Best Dad in the whole world. Merry Christmas. I love you. You are the

best. You are so kind and so nice. I love you to a million stars and to a million moons and back. I love you so much. Mia"

My mom, Dianne Silich. There are no words to describe how much I love you. And for the words you sent me on February 23, 2024:

"Stephan, I miss you already. Wished you lived closer. I'm going to make more trips to New York. You blow me away with what a good father you are and an unbelievable human being. It is really heartwarming and hopefully it will pay off in the end with two beautiful daughters. I love you all very, very, very much. Have a safe trip going home. I'm giving you hugs and kisses, always. Mom"

My brother, Robert Silich. I love you. You are, by far, the last American Gentleman. I never felt closer to anyone, but you.
And for the words you sent me on January 19, 2024:

"Well I waited until I had a quiet moment to read the best present I have ever or will ever receive... your best work yet (the poem: 'the landscape of living').

Simple, pure and beautiful in every word. I've never felt closer to you than this past year. Even more than when we lost Dad. After 9/11, I carried a small note in my wallet in case I was somehow killed or died suddenly... it was short and simple and was a note to you only.

It said I loved you more than anything or anyone and to take care of Mom and Dad and above all be happy. Last year I got rid of it after realizing that you would always be happy because of Emma and Mia, and their love. This poem now is my new note. I'll always be with you... I love you. Always... R"

My dad, Robert Silich. I love you and miss you every day.
And for the words you sent me on October 11, 2006 (after your 65th birthday):

"Stephan, Thank you for all you did for my birthday surprise. Besides the superlative speech and kind words, you have always made me proud of you. You are my greatest gift. No words express the depth of my love for you. Dad"

And the others, the very few others, you know who you are.
Thank you for the privilege of loving you and being loved.

About the Author

"Silich slips effortlessly into a long tradition of New York poets from Whitman to Frank O'Hara and his poems are a delight."

– KIRKUS REVIEWS

Stephan Silich is an award-winning writer and poet. His second collection, 'tonight is the longest night of them all' was a finalist in the 2021 Next Generation Independent Book Awards. His first collection, 'the silence between what i think and what i say' released in 2018 also received rave reviews.

Silich continues to write daily and has several more collections in the works. He lives in Manhattan and East Hampton with his two daughters, Emma and Mia.

Connect with Stephan on Instagram @stephan_silich

Thank You for Reading
Remember Me as a Time of Day

If you enjoyed this book, please consider leaving a
short review on Goodreads or your platform of choice.

Reviews help both readers and writers.
They are an easy say to support good work and help to
encourage the continued release of quality content.

Want the latest from the Brooklyn Writers Press?
Browse our complete catalog.
brooklynwriterspress.com

BROOKLYN
Writers Press

Printed in the USA
CPSIA information can be obtained
at www.ICGtesting.com
LVHW021943291024
795151LV00015B/32